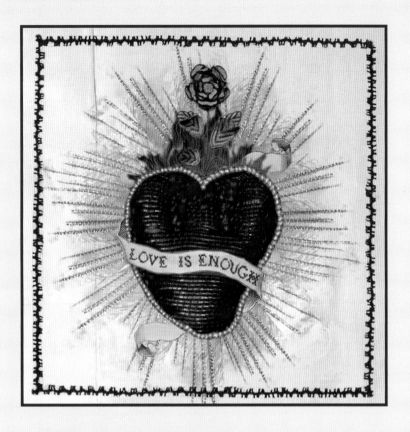

Poetry Threaded with Love

Andrea Zanatelli

with a Foreword by **Florence Welch**

Andrews McMeel
PUBLISHING®

CONTENTS

FOREWORD

The world of Instagram can be a dark and stormy sea, but sometimes you find buried treasure. Zanatelli's Instagram page is a place of ingenuity, heart, and beauty. Proving that the digital world has soul. Each painstaking piece of artwork is an exquisite blending of the past and future. Weaving together poetry, art, texture, and technology.

Zanatelli is truly an artist for our age, his digital embroidery could be considered modern-day memento mori. Sacred icons created for our current cathedrals, for who at this point cannot call their phone an altar.

Like the Romantic poets that came before Andrea, Love reigns supreme. They have a commitment to beauty

that defies decay, defies death. These poets are long gone, but their work lives on. William Blake, Emily Dickinson, Sarah Teasdale, and Sir Walter Scott each try to capture the human heart. To hold it aloft. An object of wonder and reverence. Just as Zanatelli enshrines his hearts, which are pierced by arrows, beset by flames, and struck by lightning, but never fading, forever beating.

The world has always been dark and full of peril, in Blake's time as it is in ours, but there will always be a place for the romantics and the visionaries, those who believe that love is enough.

Florence Welch

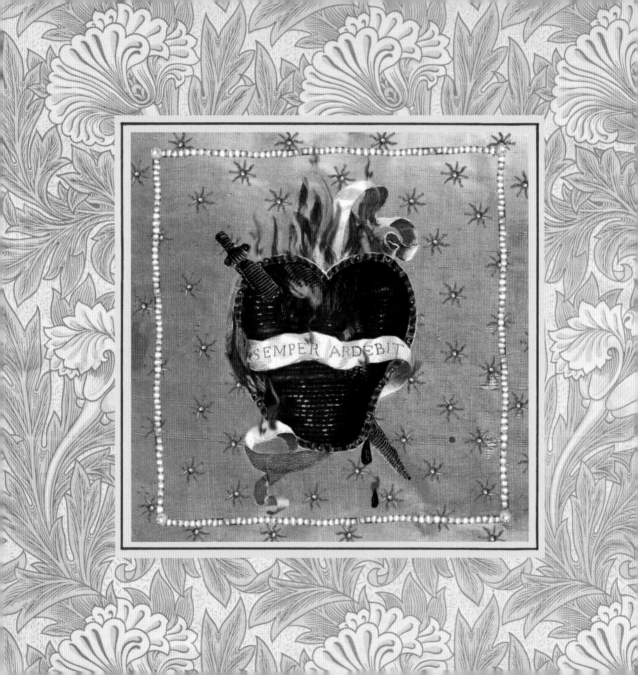

INTRODUCTION

Poetry has always been an important part of my work. I have always found great inspiration in the words of poets, as a line or a stanza often recalls an entire image, drawing you into the world of the poet.

I owe a lot to William Blake, the Arts and Crafts movement, and their exponents. Often for them, words and images became one, an extension of their philosophy. I always found that fascinating. I have not been blessed with the gift of poetry and I am not a poet. But their words certainly hold a very strong influence over me.

And so it is that in my collages, words which are not mine are woven together and my own imagery begins to emerge. Often, the words of the poems offer just a suggestion of an image, in some cases the words are taken literally and become images. Images that try to be true to the heart of those poems and to the love that I have for them.

This is *Love is Enough*: a collection of love and poetry blending together.

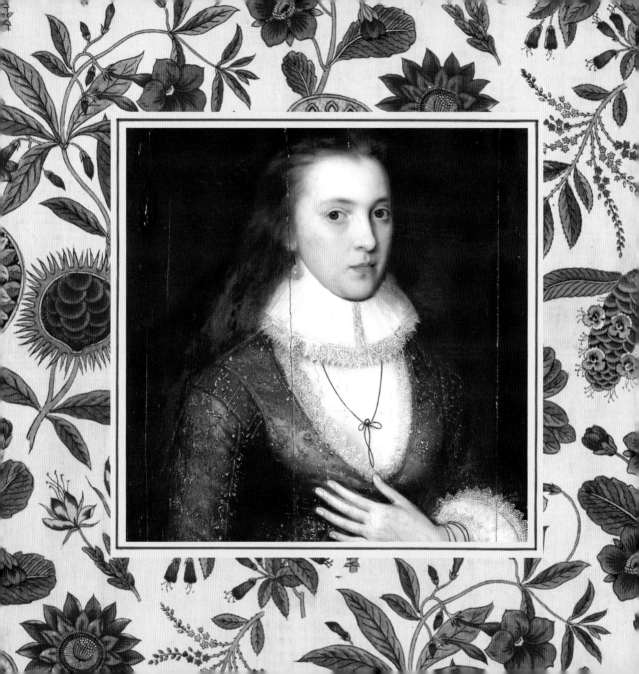

A Poor – Torn Heart – a Tattered Heart

by Emily Dickinson
(1830–86)

A poor – torn heart – a tattered heart
That sat it down to rest,
Nor noticed that the ebbing day
Flowed silver to the west;
Nor noticed night did soft descend,
Nor constellation burn,
Intent upon the vision
Of latitudes unknown.

The angels, happening that way,
This dusty heart espied;
Tenderly took it up from toil,
And carried it to God.
There – sandals for the barefoot;
There – gathered from the gales,
Do the blue havens by the hand
Lead the wandering sails.

The Sick Rose

by William Blake
(1757–1827)

O Rose thou art sick.
The invisible worm,
That flies in the night
In the howling storm:

Has found out thy bed
Of crimson joy:
And his dark secret love
Does thy life destroy.

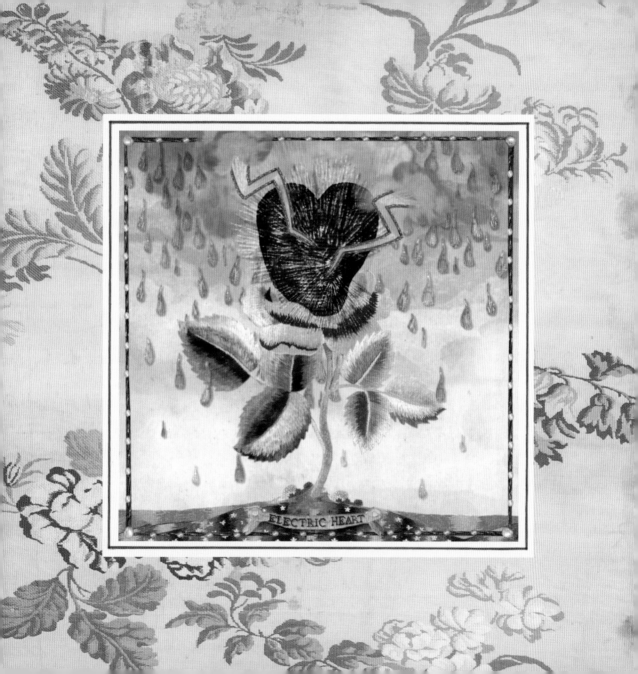

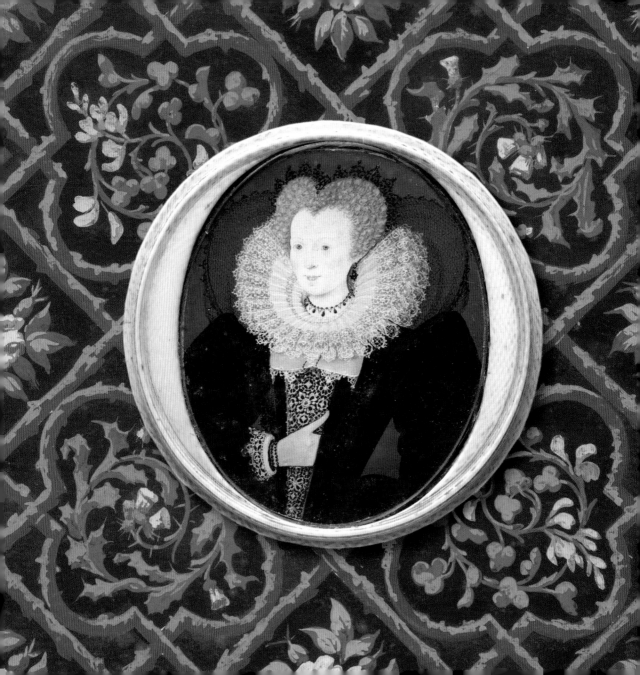

The Sonnets XCIX

The forward violet thus did I chide

by William Shakespeare
(1564–1616)

The forward violet thus did I chide:
Sweet thief, whence didst thou steal thy sweet that smells,
If not from my love's breath? The purple pride
Which on thy soft cheek for complexion dwells
In my love's veins thou hast too grossly dyed.
The lily I condemnèd for thy hand,
And buds of marjoram had stol'n thy hair;
The roses fearfully on thorns did stand,
One blushing shame, another white despair;
A third, nor red nor white, had stol'n of both,
And to his robb'ry had annexed thy breath;
But for his theft, in pride of all his growth
A vengeful canker ate him up to death.
More flow'rs I noted, yet I none could see
But sweet or colour it had stol'n from thee.

Love (*Fragment*)

by Sir Walter Scott
(1771–1832)

In peace, Love tunes the shepherd's reed;
In war, he mounts the warrior's steed;
In halls, in gay attire is seen;
In hamlets, dances on the green.
Love rules the court, the camp, the grove,
And men below and saints above;
For love is heaven, and heaven is love.

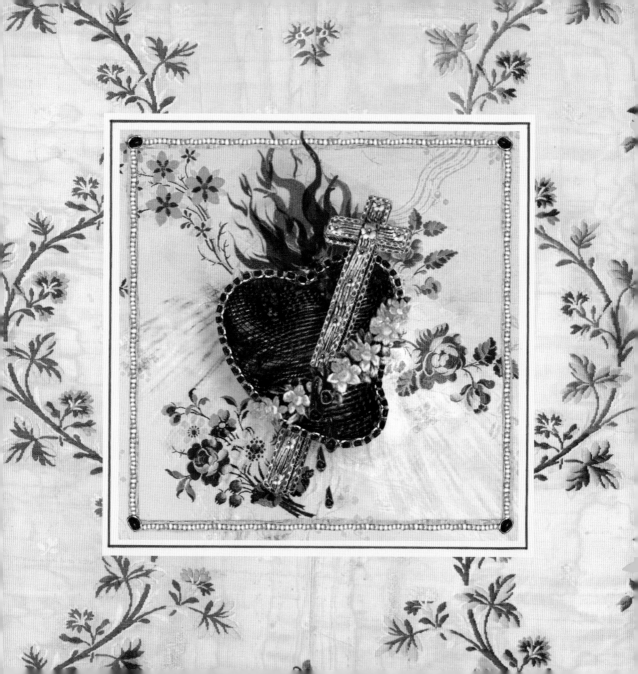

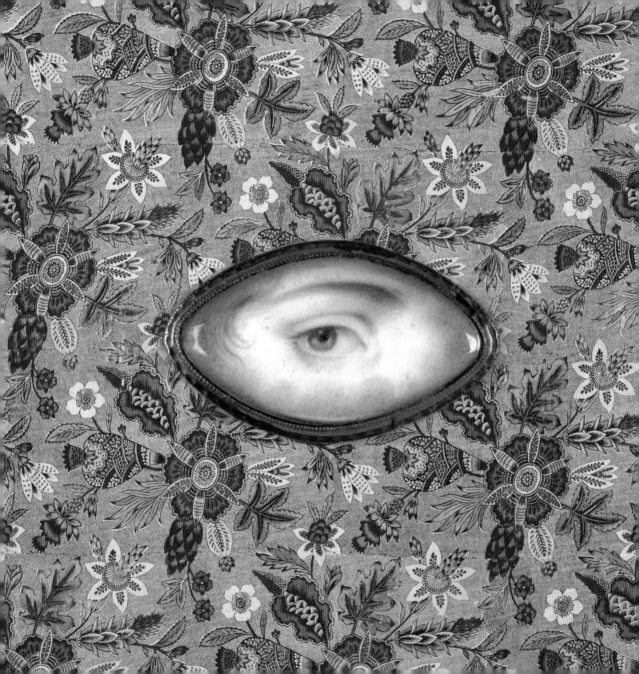

Love's Secret

by William Blake
(1757–1827)

Never seek to tell thy love,
Love that never told can be;
For the gentle wind does move
Silently, invisibly.

I told my love, I told my love,
I told her all my heart;
Trembling, cold, in ghastly fears,
Ah! she did depart!

Soon as she was gone from me,
A traveller came by,
Silently, invisibly
He took her with a sigh.

May Day

by Sara Teasdale
(1884–1933)

A delicate fabric of bird song
Floats in the air,
The smell of wet wild earth
Is everywhere.

Red small leaves of the maple
Are clenched like a hand,
Like girls at their first communion
The pear trees stand.

Oh I must pass nothing by
Without loving it much,
The raindrop try with my lips,
The grass with my touch;

For how can I be sure
I shall see again
The world on the first of May
Shining after the rain?

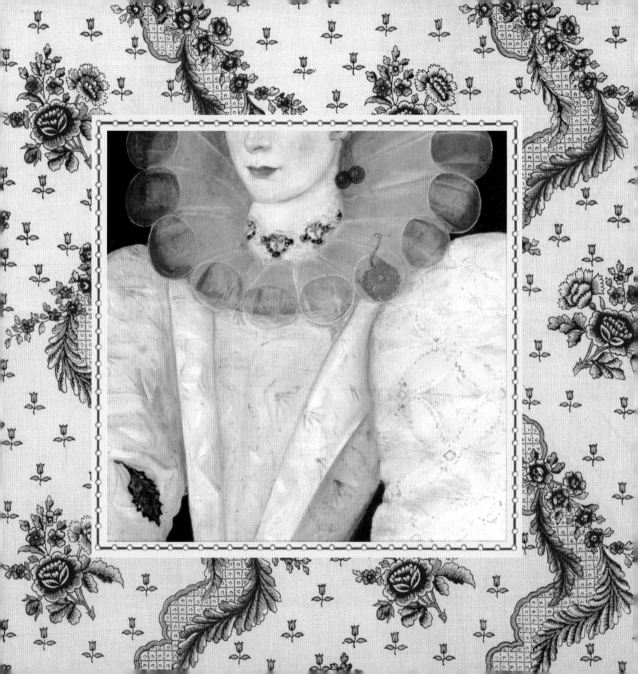

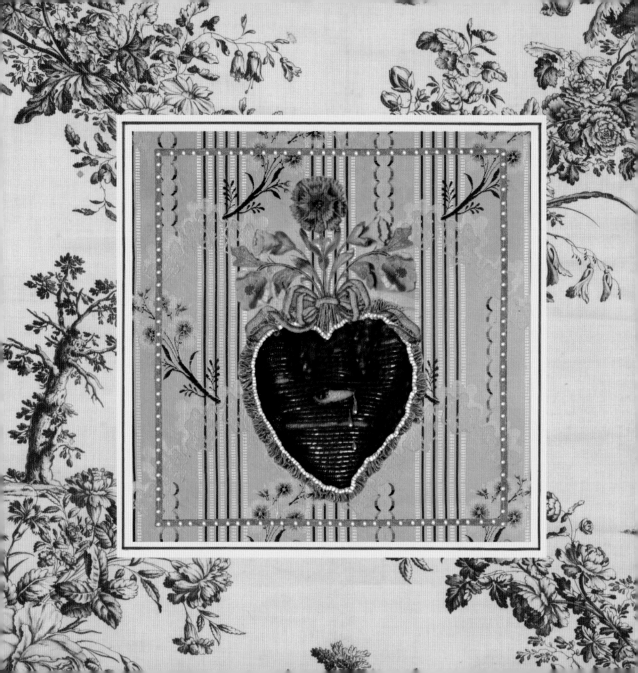

The Blossom

by William Blake
(1757–1827)

Merry Merry Sparrow
Under leaves so green
A happy Blossom
Sees you swift as arrow
Seek your cradle narrow
Near my Bosom.

Pretty Pretty Robin
Under leaves so green
A happy Blossom
Hears you sobbing sobbing
Pretty Pretty Robin
Near my Bosom.

The Sonnets CII

My love is strengthen'd, though more weak in seeming

by William Shakespeare
(1564–1616)

My love is strengthen'd, though more weak in seeming;
I love not less, though less the show appear;
That love is merchandized whose rich esteeming
The owner's tongue doth publish everywhere.
Our love was new, and then but in the spring,
When I was wont to greet it with my lays;
As Philomel in summer's front doth sing,
And stops her pipe in growth of riper days:
Not that the summer is less pleasant now
Than when her mournful hymns did hush the night,
But that wild music burthens every bough,
And sweets grown common lose their dear delight.
Therefore like her, I sometime hold my tongue,
Because I would not dull you with my song.

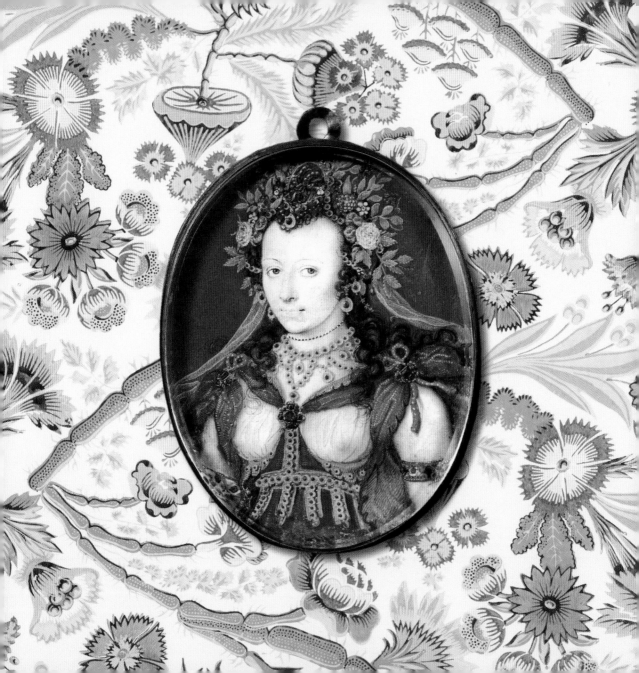

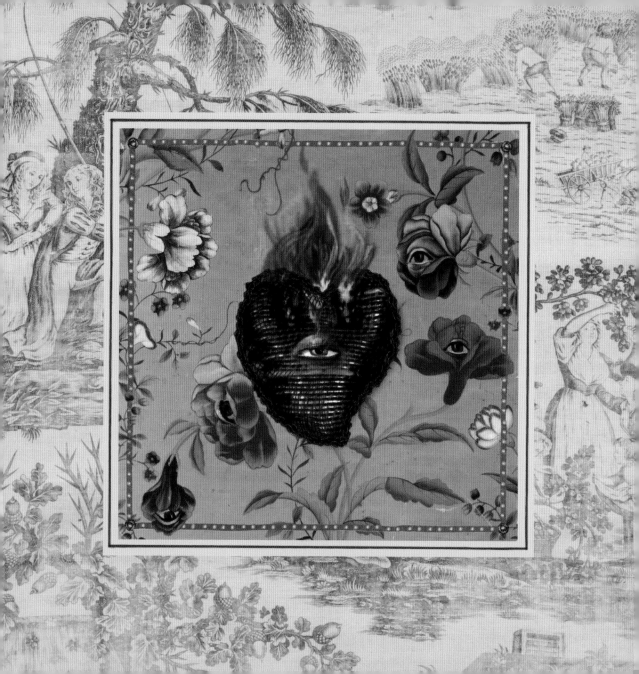

Dreams

by Anne Brontë
(1820–49)

While on my lonely couch I lie,
I seldom feel myself alone,
For fancy fills my dreaming eye
With scenes and pleasures of its own.

Then I may cherish at my breast
An infant's form beloved and fair,
May smile and soothe it into rest
With all a Mother's fondest care.

How sweet to feel its helpless form
Depending thus on me alone!
And while I hold it safe and warm
What bliss to think it is my own!

And glances then may meet my eyes
That daylight never showed to me;
What raptures in my bosom rise,
Those earnest looks of love to see,

To feel my hand so kindly prest,
To know myself beloved at last,
To think my heart has found a rest,
My life of solitude is past!

But then to wake and find it flown,
The dream of happiness destroyed,
To find myself unloved, alone,
What tongue can speak the dreary void?

A heart whence warm affections flow,
Creator, thou hast given to me,
And am I only thus to know
How sweet the joys of love would be?

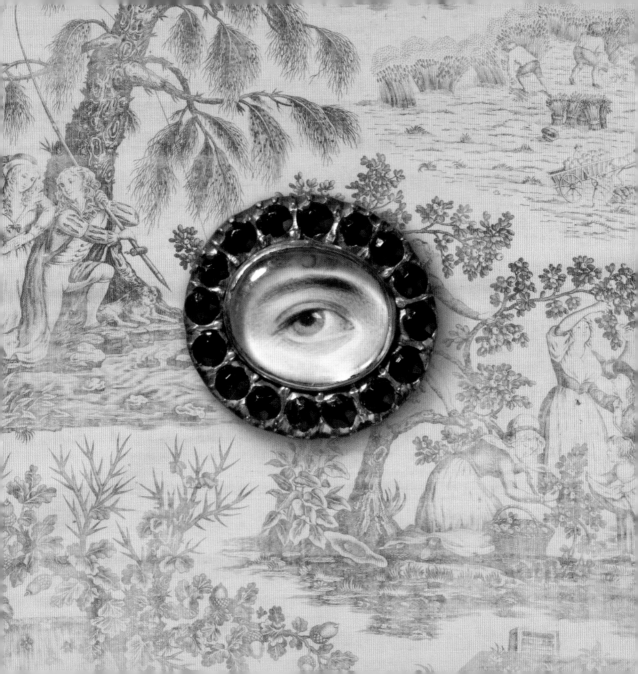

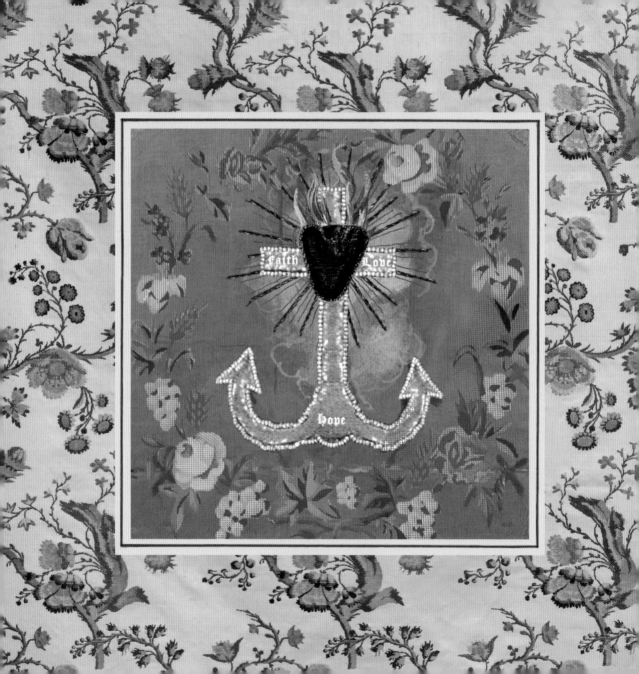

Alchemy

by Sara Teasdale
(1884–1933)

I lift my heart as spring lifts up
A yellow daisy to the rain;
My heart will be a lovely cup
Altho' it holds but pain.

For I shall learn from flower and leaf
That color every drop they hold,
To change the lifeless wine of grief
To living gold.

Night

by Anne Brontë
(1820–49)

I love the silent hour of night,
For blissful dreams may then arise,
Revealing to my charmèd sight
What may not bless my waking eyes.

And then a voice may meet my ear
That death has silenced long ago;
And hope and rapture may appear
Instead of solitude and woe.

Cold in the grave for years has lain
The form it was my bliss to see;
And only dreams can bring again,
The darling of my heart to me.

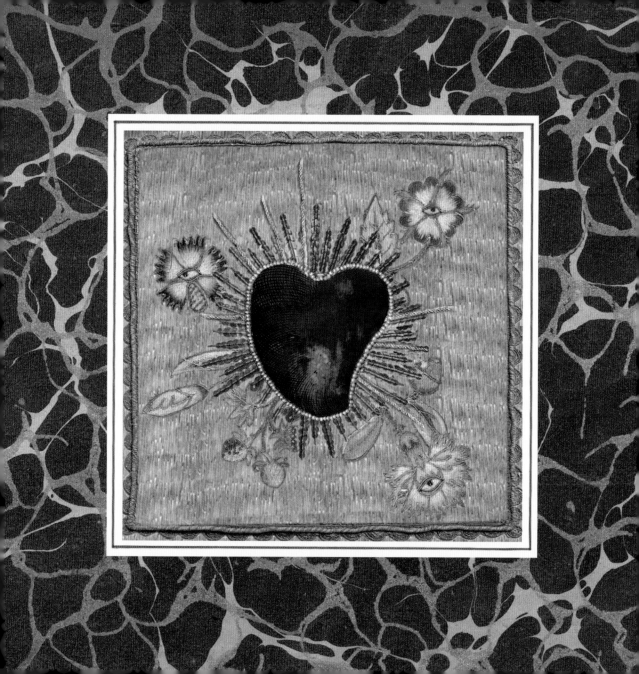

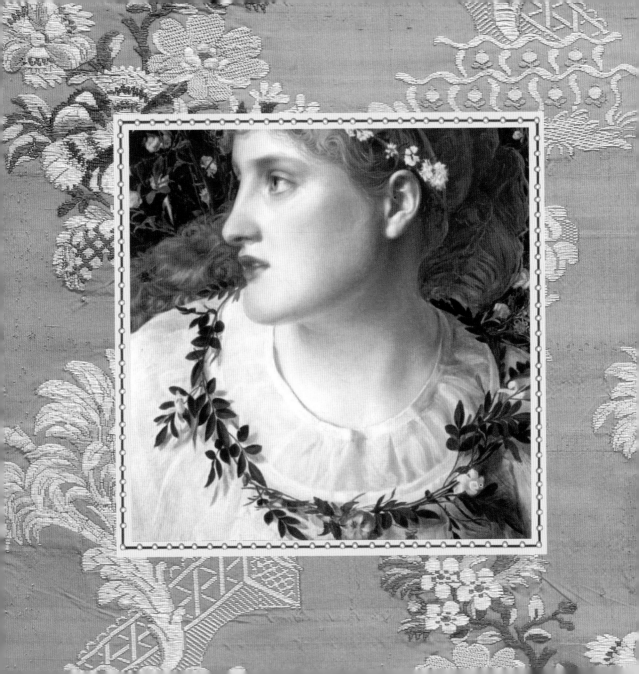

The Lilly

by William Blake
(1757–1827)

The modest Rose puts forth a thorn,
The humble sheep a threat'ning horn:
While the Lilly white shall in love delight,
Nor a thorn nor a threat stain her beauty bright.

After Love

by Sara Teasdale
(1884–1933)

There is no magic any more,
We meet as other people do,
You work no miracle for me
Nor I for you.

You were the wind and I the sea –
There is no splendor any more,
I have grown listless as the pool
Beside the shore.

But though the pool is safe from storm
And from the tide has found surcease,
It grows more bitter than the sea,
For all its peace.

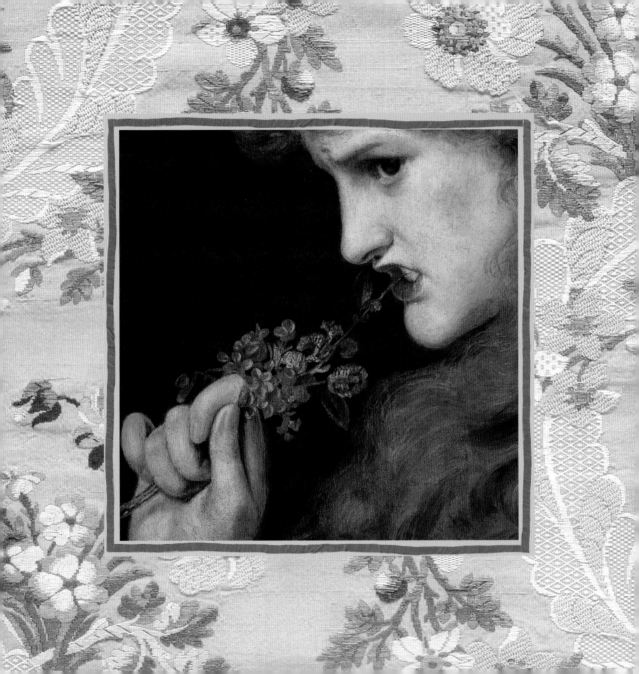

Power of Love

by Anne Brontë
(1820–49)

Love, indeed thy strength is mighty
Thus, alone, such strife to bear –
Three 'gainst one, and never ceasing –
Death, and Madness, and Despair!

'Tis not my own strength has saved me;
Health, and hope, and fortitude,
But for love, had long since failed me;
Heart and soul had sunk subdued.

Often, in my wild impatience,
I have lost my trust in Heaven,
And my soul has tossed and struggled,
Like a vessel tempest-driven;

But the voice of my belovèd
In my ear has seemed to say,
'O, be patient if thou lov'st me!'
And the storm has passed away.

When outworn with weary thinking,
Sight and thought were waxing dim,
And my mind began to wander,
And my brain began to swim,

Then those hands outstretched to save me
Seemed to call me back again –
Those dark eyes did so implore me
To resume my reason's reign,

That I could not but remember
How her hopes were fixed on me,
And, with one determined effort,
Rose, and shook my spirit free.

When hope leaves my weary spirit –
All the power to hold it gone –
That loved voice so loudly prays me,
'For my sake, keep hoping on,'

That, at once my strength renewing,
Though Despair had crushed me down,
I can burst his bonds asunder,
And defy his deadliest frown.

When, from nights of restless tossing,
Days of gloom and pining care,
Pain and weakness, still increasing,
Seem to whisper 'Death is near,'

And I almost bid him welcome,
Knowing he would bring release,
Weary of this restless struggle –
Longing to repose in peace,

Then a glance of fond reproval
Bids such selfish longings flee
And a voice of matchless music
Murmurs 'Cherish life for me!'

Roused to newborn strength and courage,
Pain and grief, I cast away,
Health and life, I keenly follow,
Mighty Death is held at bay.

Yes, my love, I will be patient!
Firm and bold my heart shall be:
Fear not – though this life is dreary,
I can bear it well for thee.

Let our foes still rain upon me
Cruel wrongs and taunting scorn;
'Tis for thee their hate pursues me,
And for thee, it shall be borne!

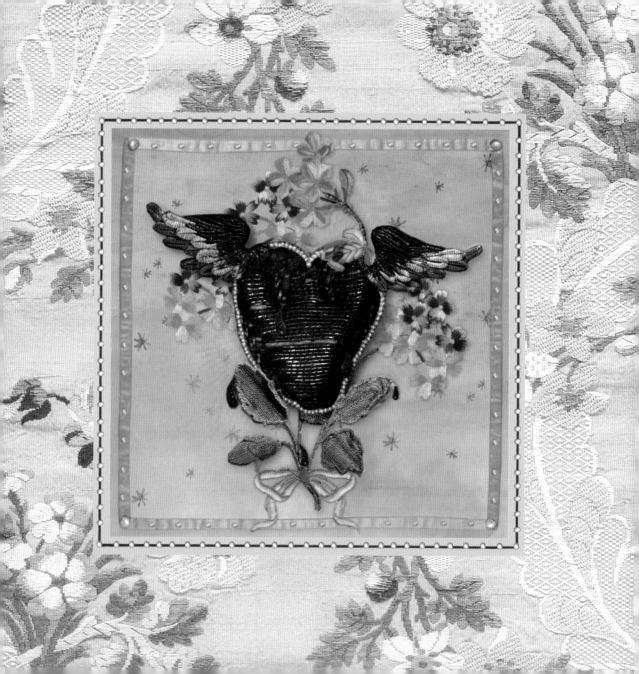

A Bridal Song

by Percy Bysshe Shelley
(1792–1822)

1. The golden gates of Sleep unbar
 Where Strength and Beauty, met together,
 Kindle their image like a star
 In a sea of glassy weather!
 Night, with all thy stars look down, –
 Darkness, weep thy holiest dew, –
 Never smiled the inconstant moon
 On a pair so true.
 Let eyes not see their own delight; –
 Haste, swift Hour, and thy flight
 Oft renew.

2. Fairies, sprites, and angels, keep her!
 Holy stars, permit no wrong!
 And return to wake the sleeper,
 Dawn, – ere it be long!
 O joy! O fear! what will be done
 In the absence of the sun!
 Come along!

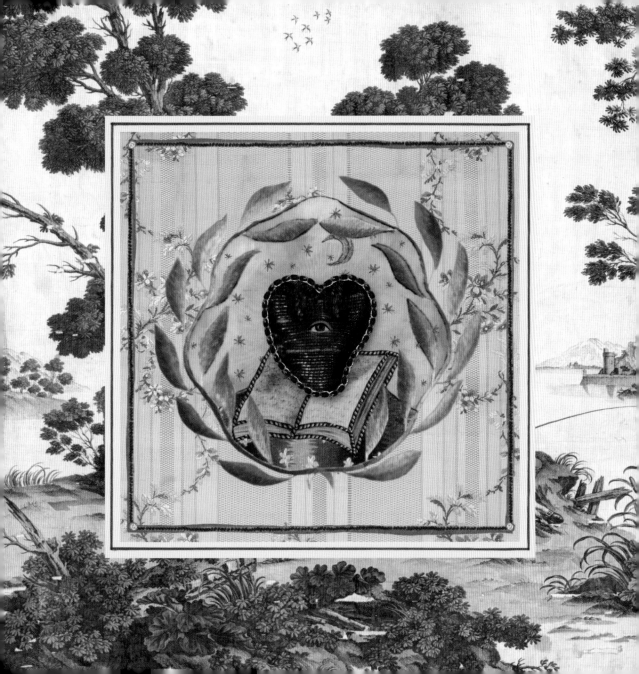

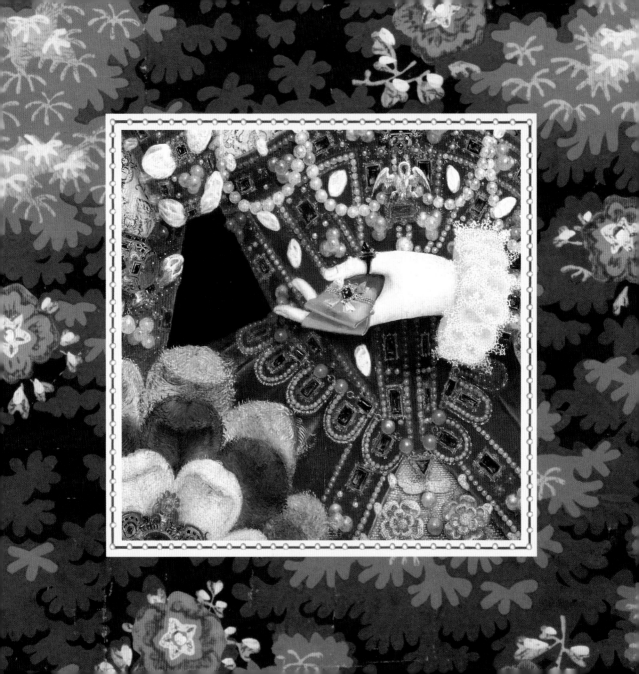

Presage

by Violet Jacob
(1863–1946)

The year declines, and yet there is
 A clearness, as of hinted spring;
And chilly, like a virgin's kiss,
 The cold light touches everything.

The world seems dazed with purity,
 There hangs, this spell-bound afternoon,
Beyond the naked cherry tree
 The new-wrought sickle of the moon.

What is this thraldom, pale and still,
 That holds so passionless a sway?
Lies death in this ethereal chill,
 New life, or prelude of decay?

In the frail rapture of the sky
 There bodes, transfigured, far aloof,
The veil that hides eternity,
 With life for warp and death for woof.

We see the presage – not with eyes,
 But dimly, with the shrinking soul –
Scarce guessing, in this fateful guise,
 The glory that enwraps the whole,

The light no flesh may apprehend,
 Lent but to spirit-eyes, to give
Sign of that splendour of the end
 That none may look upon and live.

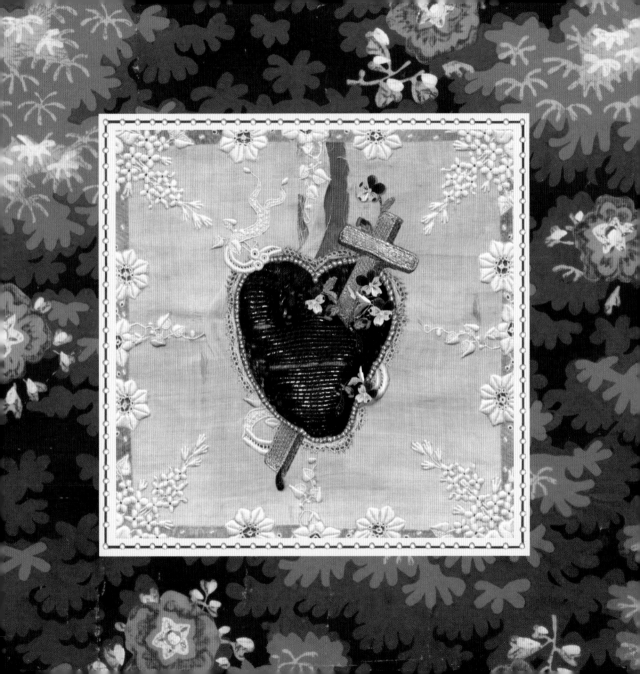

Love is Strong as Death

by Christina Rossetti
(1830–94)

'I have not sought Thee, I have not found Thee,
I have not thirsted for Thee:
And now cold billows of death surround me,
Buffeting billows of death astound me, –
Wilt Thou look upon, wilt Thou see
Thy perishing me?'

'Yea, I have sought thee, yea, I have found thee,
Yea, I have thirsted for thee,
Yea, long ago with love's bands I bound thee:
Now the Everlasting Arms surround thee, –
Through death's darkness I look and see
And clasp thee to Me.'

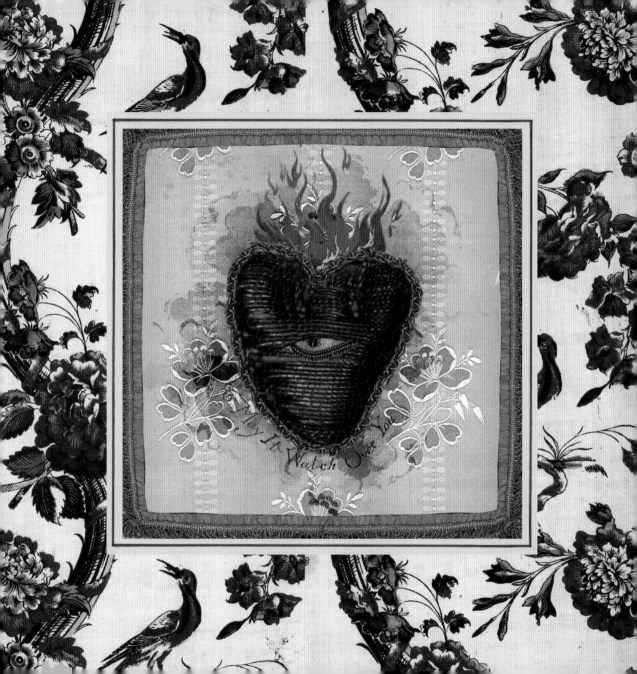

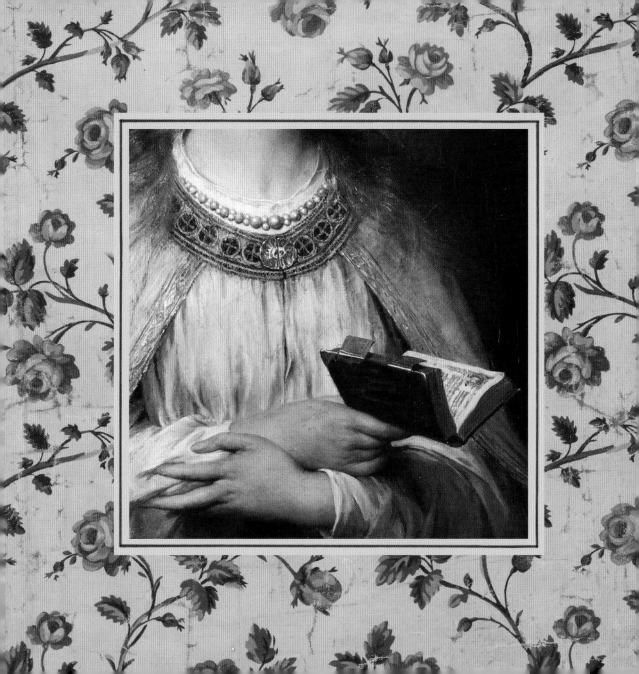

To Mary Shelley

by Percy Bysshe Shelley
(1792–1822)

My dearest Mary, wherefore hast thou gone,
And left me in this dreary world alone?
Thy form is here indeed – a lovely one –
But thou art fled, gone down the dreary road,
That leads to Sorrow's most obscure abode;
Thou sittest on the hearth of pale despair,
Where
For thine own sake I cannot follow thee.

The Garden of Love

by William Blake
(1757–1827)

I went to the Garden of Love.
And saw what I never had seen:
A Chapel was built in the midst,
Where I used to play on the green.

And the gates of this Chapel were shut,
And Thou shalt not. writ over the door;
So I turn'd to the Garden of Love,
That so many sweet flowers bore.

And I saw it was filled with graves,
And tomb-stones where flowers should be:
And Priests in black gowns, were walking their rounds,
And binding with briars, my joys & desires.

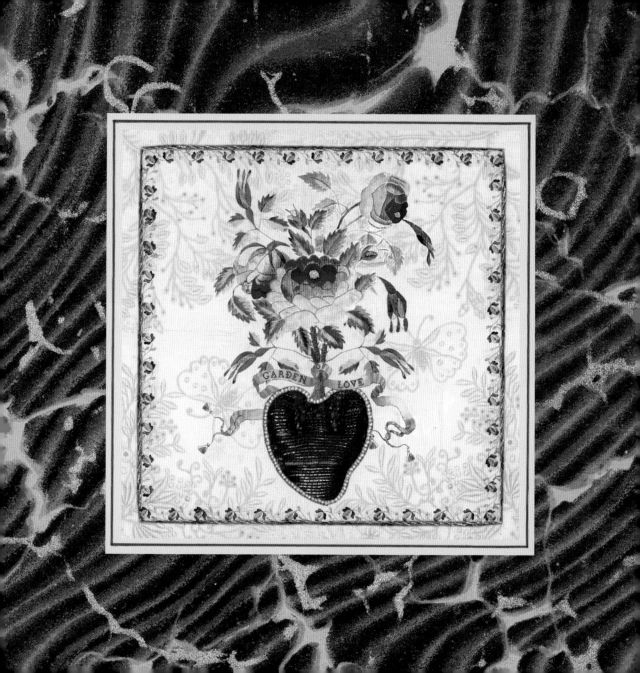

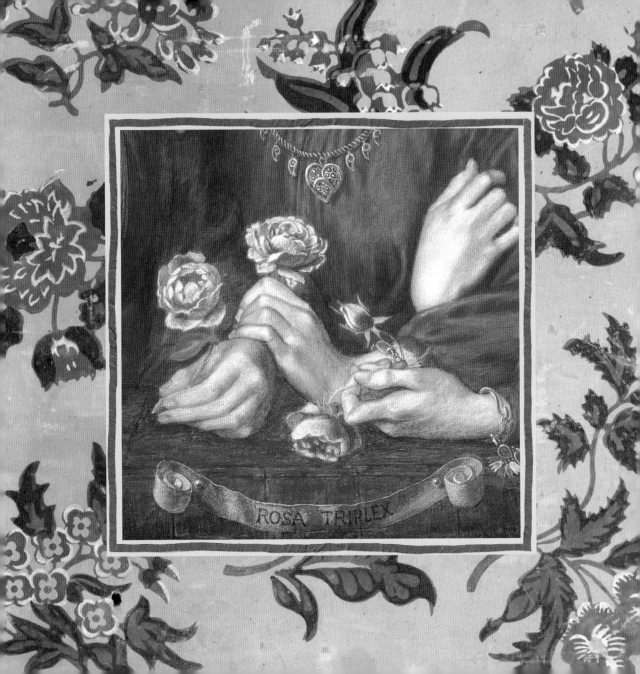

ROSA TRIPLEX

Love's Rose

by Percy Bysshe Shelley
(1792–1822)

1. Hopes, that swell in youthful breasts,
 Live not through the waste of time!
 Love's rose a host of thorns invests;
 Cold, ungenial is the clime,
 Where its honours blow.
 Youth says, 'The purple flowers are mine,'
 Which die the while they glow.

2. Dear the boon to Fancy given,
 Retracted whilst it's granted:
 Sweet the rose which lives in Heaven,
 Although on earth 'tis planted,
 Where its honours blow,
 While by earth's slaves the leaves are riven
 Which die the while they glow.

3. Age cannot Love destroy,
 But perfidy can blast the flower,
 Even when in most unwary hour
 It blooms in Fancy's bower.
 Age cannot Love destroy,
 But perfidy can rend the shrine
 In which its vermeil splendours shine.

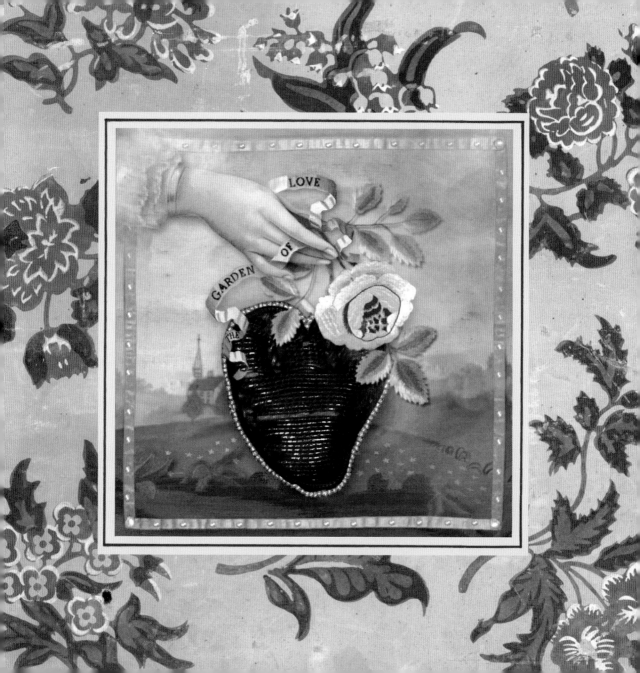

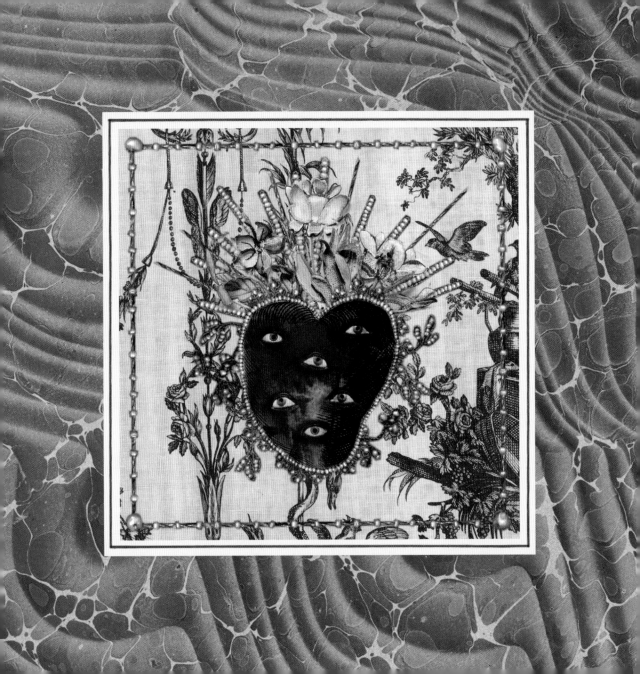

Love and Time

by Thomas Moore
(1779–1852)

'Tis said – but whether true or not
 Let bards declare who've seen 'em –
That Love and Time have only got
 One pair of wings between 'em.
In Courtship's first delicious hour,
 The boy full oft can spare 'em;
So, loitering in his lady's bower,
 He lets the gray-beard wear 'em.
 Then is Time's hour of play;
 Oh, how he flies, flies away!

But short the moments, short as bright,
　　When he the wings can borrow;
If Time to-day has had his flight,
　　Love takes his turn to-morrow.
Ah! Time and Love, your change is then
　　The saddest and most trying,
When one begins to limp again,
　　And t'other takes to flying.
　　　　Then is Love's hour to stray;
　　　　Oh, how he flies, flies away!

But there's a nymph, whose chains I feel,
　　And bless the silken fetter,
Who knows, the dear one, how to deal
　　With Love and Time much better.
So well she checks their wanderings,
　　So peacefully she pairs 'em,
That Love with her ne'er thinks of wings,
　　And Time for ever wears 'em.
　　　　This is Time's holiday;
　　　　Oh, how he flies, flies away!

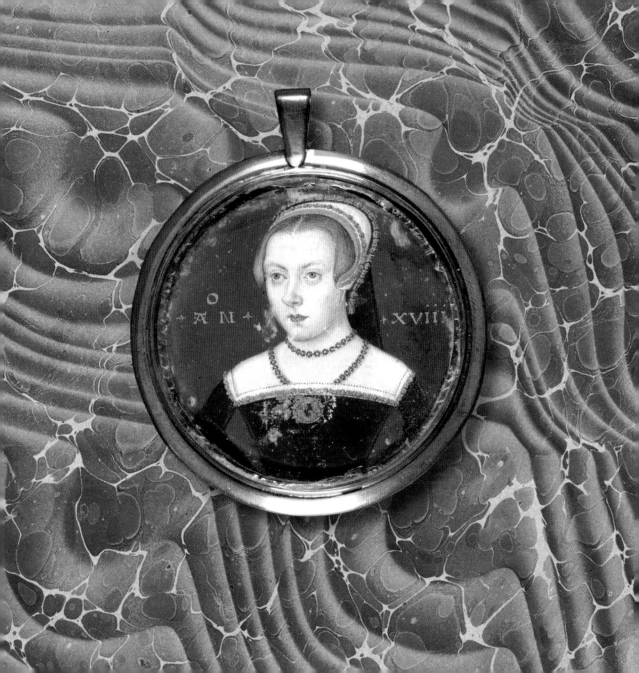

The Sonnets XL

Take all my loves, my love; yea, take them all

by William Shakespeare
(1564–1616)

Take all my loves, my love; yea, take them all.
What hast thou then more than thou hadst before?
No love, my love, that thou mayst true love call.
All mine was thine before thou hadst this more.
Then if for my love thou my love receivest,
I cannot blame thee, for my love thou usest.
But yet be blamed, if thou thy self deceivest
By wilful taste of what thyself refusest.
I do forgive thy robb'ry, gentle thief,
Although thou steal thee all my poverty;
And yet love knows it is a greater grief
To bear love's wrong than hate's known injury.
Lascivious grace, in whom all ill well shows,
Kill me with spites; yet we must not be foes.

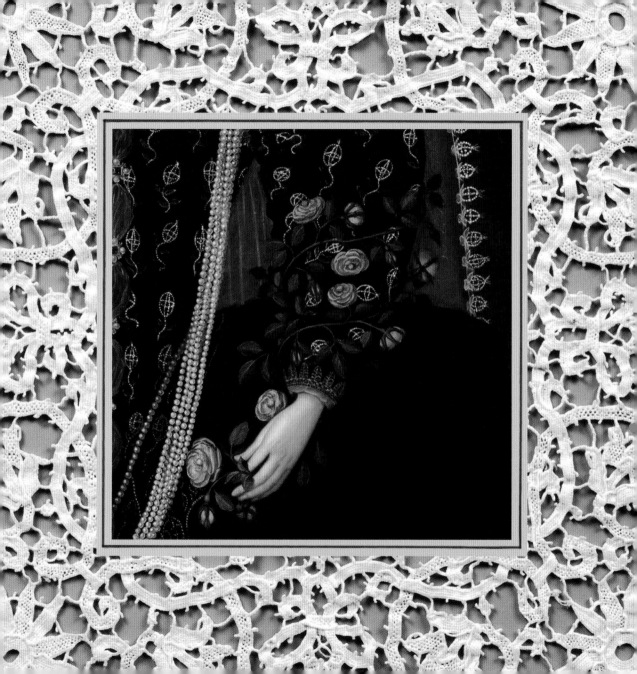

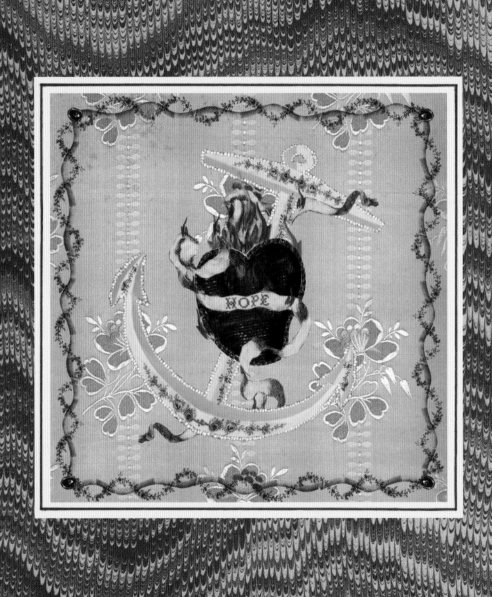

Love, Hope, Desire, and Fear

by Percy Bysshe Shelley
(1792–1822)

And many there were hurt by that strong boy,
His name, they said, was Pleasure,
And near him stood, glorious beyond measure
Four Ladies who possess all empery
In earth and air and sea,
Nothing that lives from their award is free.
Their names will I declare to thee,
Love, Hope, Desire, and Fear,
And they the regents are
Of the four elements that frame the heart,

And each diversely exercised her art
By force or circumstance or sleight
To prove her dreadful might
Upon that poor domain.
Desire presented her [false] glass, and then
The spirit dwelling there
Was spellbound to embrace what seemed so fair
Within that magic mirror,
And dazed by that bright error,
It would have scorned the [shafts] of the avenger
And death, and penitence, and danger,
Had not then silent Fear
Touched with her palsying spear,
So that as if a frozen torrent
The blood was curdled in its current;
It dared not speak, even in look or motion,
But chained within itself its proud devotion.
Between Desire and Fear thou wert
A wretched thing, poor heart!
Sad was his life who bore thee in his breast,
Wild bird for that weak nest.
Till Love even from fierce Desire it bought,

And from the very wound of tender thought
Drew solace, and the pity of sweet eyes
Gave strength to bear those gentle agonies,
Surmount the loss, the terror, and the sorrow.
Then Hope approached, she who can borrow
For poor to-day, from rich to-morrow,
And Fear withdrew, as night when day
Descends upon the orient ray,
And after long and vain endurance
The poor heart woke to her assurance.
 – At one birth these four were born
With the world's forgotten morn,
And from Pleasure still they hold
All it circles, as of old.
When, as summer lures the swallow,
Pleasure lures the heart to follow –
O weak heart of little wit!
The fair hand that wounded it,
Seeking, like a panting hare,
Refuge in the lynx's lair,
Love, Desire, Hope, and Fear,
Ever will be near.

Love Arm'd

by Aphra Behn
(1640–89)

Love in Fantastique Triumph satt,
Whilst bleeding Hearts around him flow'd,
For whom Fresh pains he did create,
And strange Tyranic power he show'd;
From thy Bright Eyes he took his fire,
Which round about, in sport he hurl'd;
But 'twas from mine he took desire,
Enough t'undo the Amorous World.
From me he took his sighs and tears,
From thee his Pride and Crueltie;
From me his Languishments and Feares,
And every Killing Dart from thee;
Thus thou and I, the God have arm'd,
And sett him up a Deity;
But my poor Heart alone is harm'd,
Whilst thine the Victor is, and free.

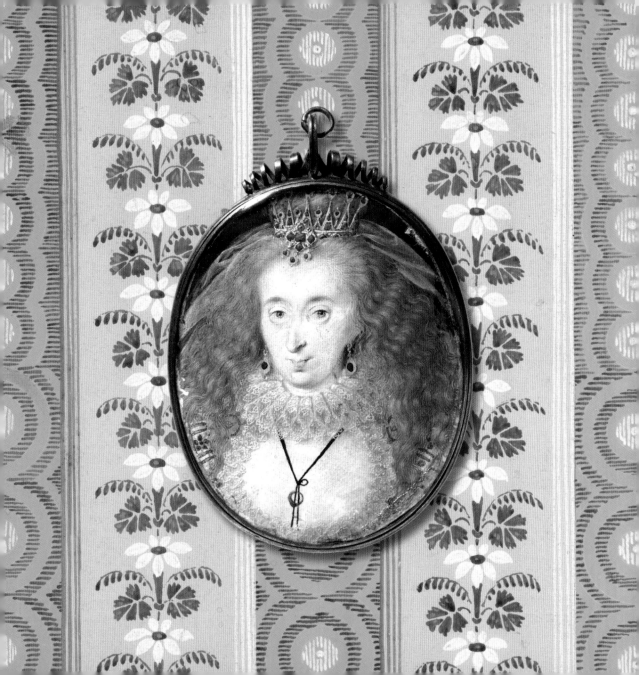

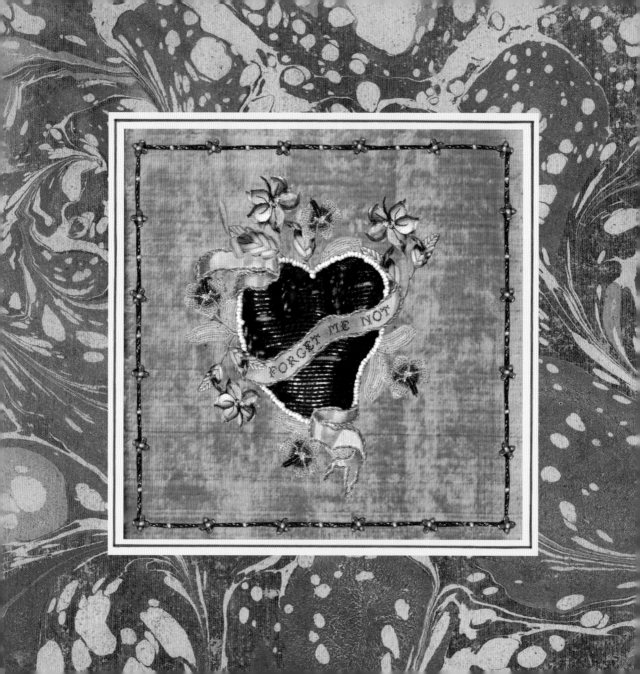

Love's Last Adieu

by George Gordon, Lord Byron
(1788–1824)

The roses of Love glad the garden of life,
Though nurtur'd 'mid weeds dropping pestilent dew,
Till Time crops the leaves with unmerciful knife,
Or prunes them for ever, in Love's last adieu!

In vain, with endearments, we soothe the sad heart,
In vain do we vow for an age to be true;
The chance of an hour may command us to part,
Or Death disunite us, in Love's last adieu!

Still Hope, breathing peace, through the grief-swollen breast,
Will whisper, 'Our meeting we yet may renew':
With this dream of deceit, half our sorrow's represt,
Nor taste we the poison, of Love's last adieu!

Oh! mark you yon pair, in the sunshine of youth,
Love twin'd round their childhood his flow'rs as they grew;
They flourish awhile, in the season of truth,
Till chill'd by the winter of Love's last adieu!

Sweet lady! why thus doth a tear steal its way,
Down a cheek which outrivals thy bosom in hue?
Yet why do I ask? – to distraction a prey,
Thy reason has perish'd, with Love's last adieu!

Oh! who is yon Misanthrope, shunning mankind?
From cities to caves of the forest he flew:
There, raving, he howls his complaint to the wind;
The mountains reverberate Love's last adieu!

Now Hate rules a heart which in Love's easy chains,
Once Passion's tumultuous blandishments knew;
Despair now inflames the dark tide of his veins,
He ponders, in frenzy, on Love's last adieu!

How he envies the wretch, with a soul wrapt in steel!
His pleasures are scarce, yet his troubles are few,
Who laughs at the pang that he never can feel,
And dreads not the anguish of Love's last adieu!

Youth flies, life decays, even hope is o'ercast;
No more, with Love's former devotion, we sue:
He spreads his young wing, he retires with the blast;
The shroud of affection is Love's last adieu!

In this life of probation, for rapture divine,
Astrea declares that some penance is due;
From him, who has worshipp'd at Love's gentle shrine,
The atonement is ample, in Love's last adieu!

Who kneels to the God, on his altar of light
Must myrtle and cypress alternately strew:
His myrtle, an emblem of purest delight,
His cypress, the garland of Love's last adieu!

Hidden Love

by Sara Teasdale
(1884–1933)

I hid the love within my heart,
And lit the laughter in my eyes,
That when we meet he may not know
My love that never dies.

But sometimes when he dreams at night
Of fragrant forests green and dim,
It may be that my love crept out
And brought the dream to him.

And sometimes when his heart is sick
And suddenly grows well again,
It may be that my love was there
To free his life of pain.

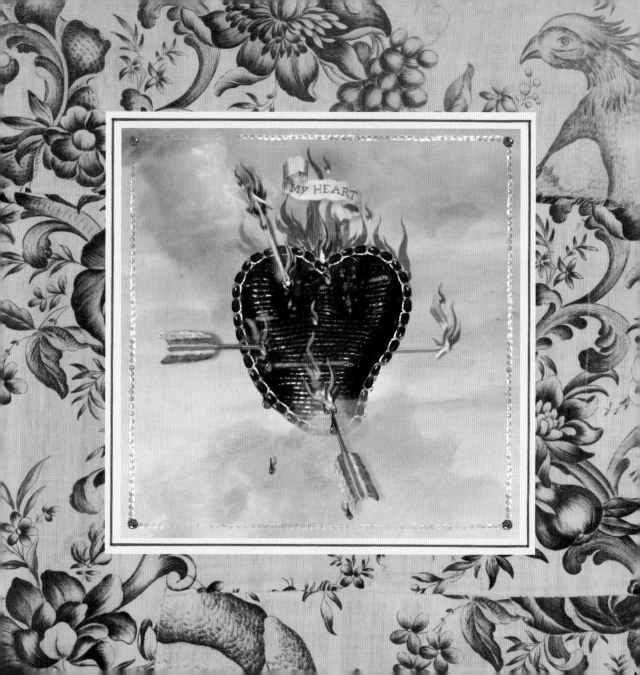

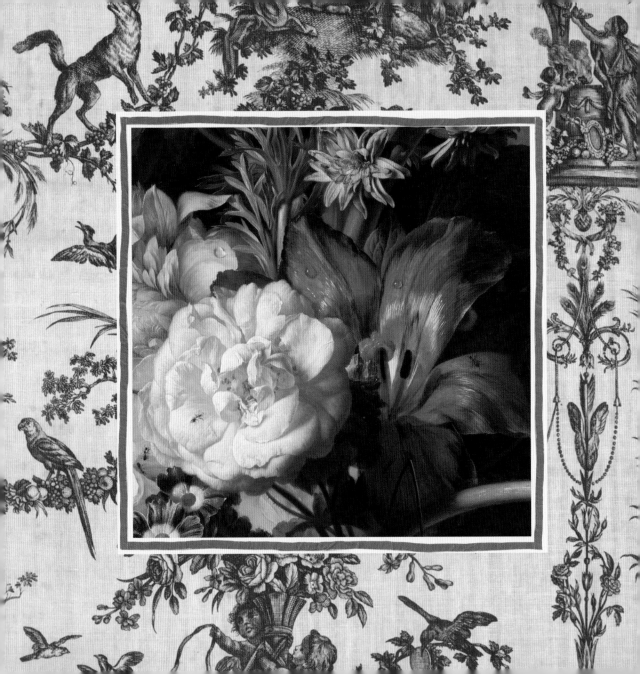

The Sonnets CLIV

The little love-god lying once asleep

by William Shakespeare
(1564–1616)

The little love-god lying once asleep
Laid by his side his heart-inflaming brand,
Whilst many nymphs that vow'd chaste life to keep
Came tripping by; but in her maiden hand
The fairest votary took up that fire,
Which many legions of true hearts had warm'd;
And so the general of hot desire
Was, sleeping, by a virgin hand disarm'd.
This brand she quenchèd in a cool well by,
Which from Love's fire took heat perpetual,
Growing a bath and healthful remedy
For men diseased; but I, my mistress' thrall,
Came there for cure, and this by that I prove:
Love's fire heats water, water cools not love.

My Pretty Rose Tree

by William Blake
(1757–1827)

A flower was offered to me,
Such a flower as May never bore;
But I said, 'I've a Pretty Rose tree,'
And I passed the sweet flower o'er.

Then I went to my Pretty Rose tree,
To tend her by day and by night;
But my Rose turned away with jealousy,
And her thorns were my only delight.

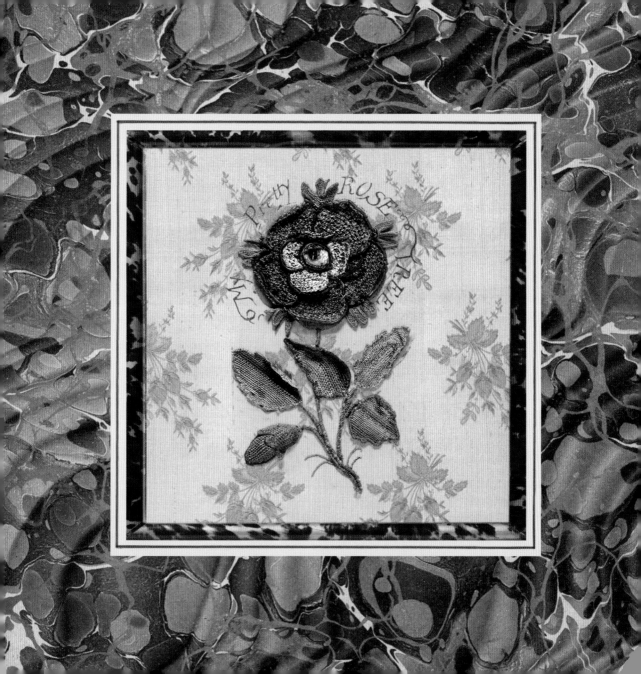

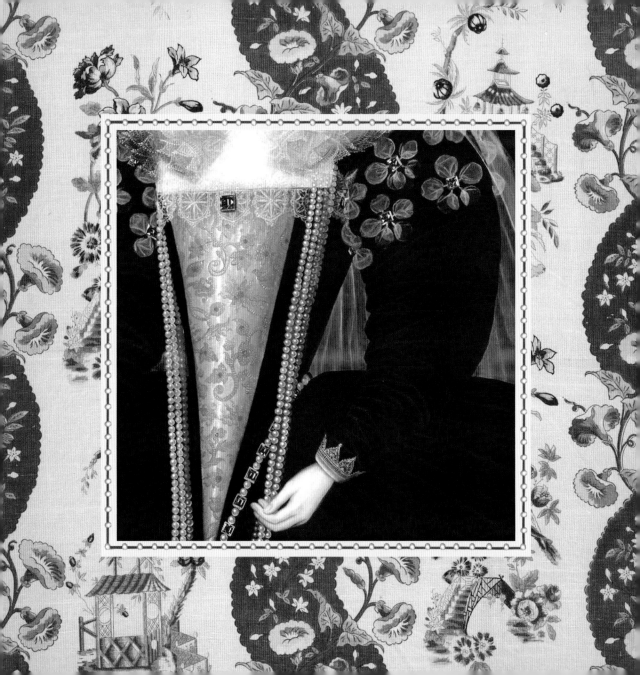

Song

by Aphra Behn
(1640–89)

O love! that stronger art than Wine,
Pleasing Delusion, Witchery divine,
Wont to be priz'd above all Wealth,
Disease that has more Joys than Health;
Though we blaspheme thee in our Pain,
And of Tyranny complain,
We are all better'd by thy Reign.

What Reason never can bestow,
We to this useful Passion owe:
Love wakes the dull from sluggish ease,
And learns a Clown the Art to please:
Humbles the Vain, kindles the Cold,
Makes Misers free, and Cowards bold;
And teaches airy Fops to think.

When full brute Appetite is fed,
And choaked the Glutton lies and dead;
Thou new Spirits dost dispense,
And fine'st the gross Delights of Sense.
Virtue's unconquerable Aid
That against Nature can persuade;
And makes a roving Mind retire
Within the Bounds of just Desire.
Chearer of Age, Youth's kind Unrest,
And half the Heaven of the blest!

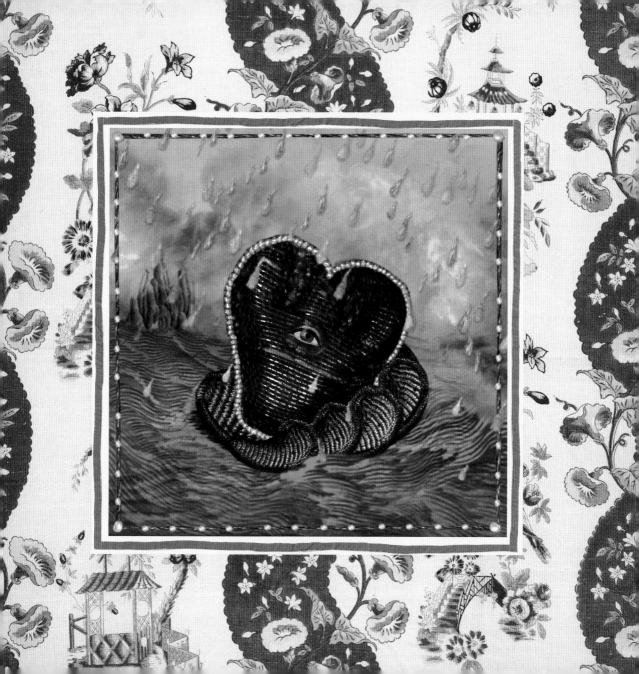

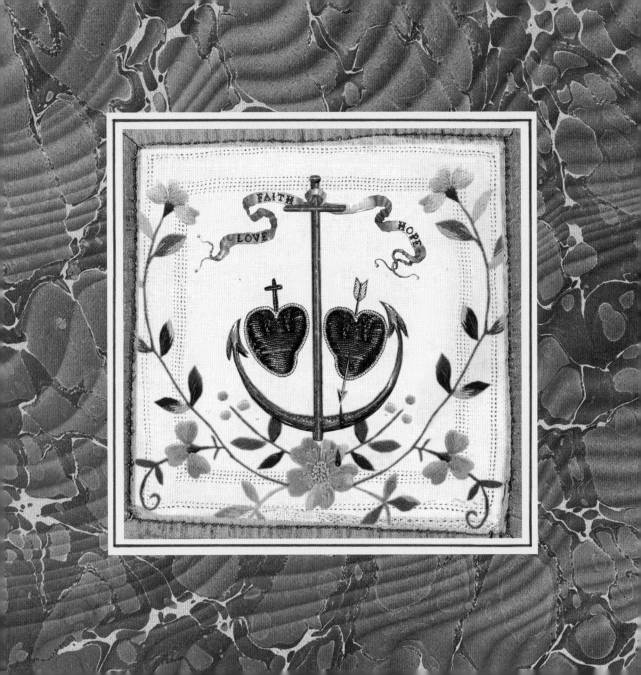

Love and Harmony

by William Blake
(1757–1827)

Love and harmony combine,
And round our souls entwine
While thy branches mix with mine,
And our roots together join.

Joys upon our branches sit,
Chirping loud and singing sweet;
Like gentle streams beneath our feet
Innocence and virtue meet.

Thou the golden fruit dost bear,
I am clad in flowers fair;
Thy sweet boughs perfume the air,
And the turtle buildeth there.

There she sits and feeds her young,
Sweet I hear her mournful song;
And thy lovely leaves among,
There is love, I hear his tongue.

There his charming nest doth lay,
There he sleeps the night away;
There he sports along the day,
And doth among our branches play.

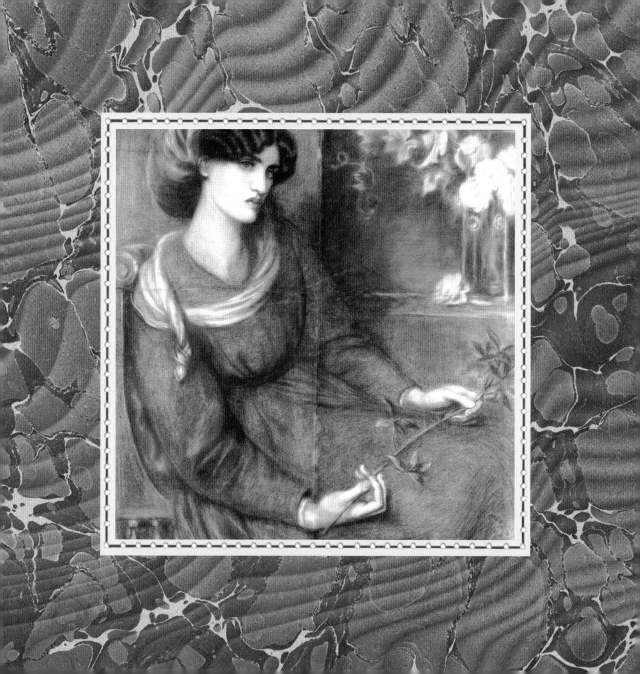

Love Songs

by Sara Teasdale
(1884–1933)

I have remembered beauty in the night,
 Against black silences I waked to see
 A shower of sunlight over Italy
And green Ravello dreaming on her height;
I have remembered music in the dark,
 The clean swift brightness of a fugue of Bach's,
 And running water singing on the rocks
When once in English woods I heard a lark.

But all remembered beauty is no more
 Than a vague prelude to the thought of you.
 You are the rarest soul I ever knew,
 Lover of beauty, knightliest and best;
My thoughts seek you as waves that seek the shore,
 And when I think of you, I am at rest.

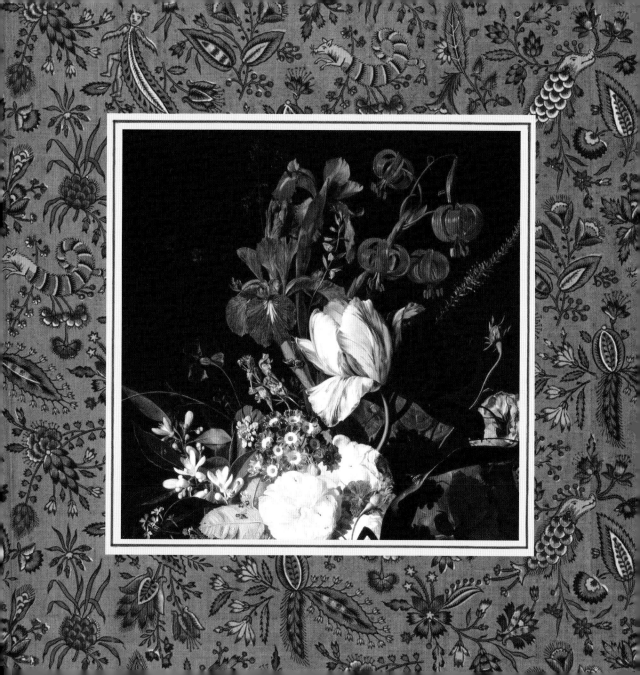

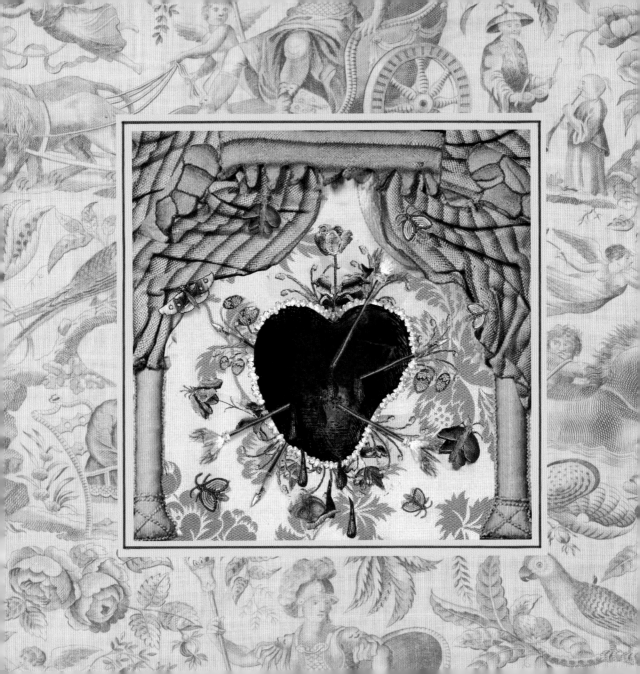

The Sonnets CLI

Love is too young to know
what conscience is

by William Shakespeare
(1564–1616)

Love is too young to know what conscience is;
Yet who knows not, conscience is born of love?
Then, gentle cheater, urge not my amiss,
Lest guilty of my faults thy sweet self prove.
For thou betraying me, I do betray
My nobler part to my gross body's treason;
My soul doth tell my body that he may
Triumph in love; flesh stays no farther reason,
But rising at thy name, doth point out thee
As his triumphant prize. Proud of this pride,
He is contented thy poor drudge to be,
To stand in thy affairs, fall by thy side.
No want of conscience hold it that I call
Her 'love', for whose dear love I rise and fall.

The Wild Flower's Song

by William Blake
(1757–1827)

As I wandered the forest,
The green leaves among,
I heard a Wild Flower
Singing a song.

'I slept in the earth
In the silent night,
I murmured my fears
And I felt delight.

'In the morning I went
As rosy as morn,
To seek for new joy;
But oh! met with scorn.'

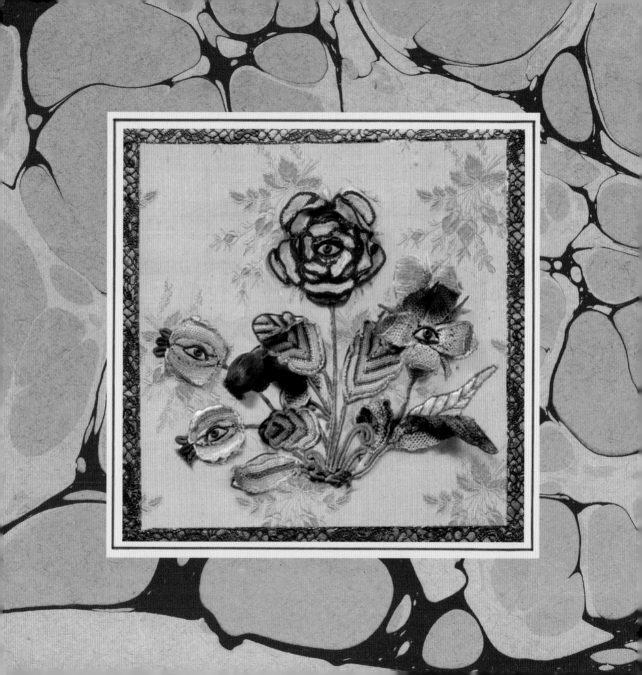

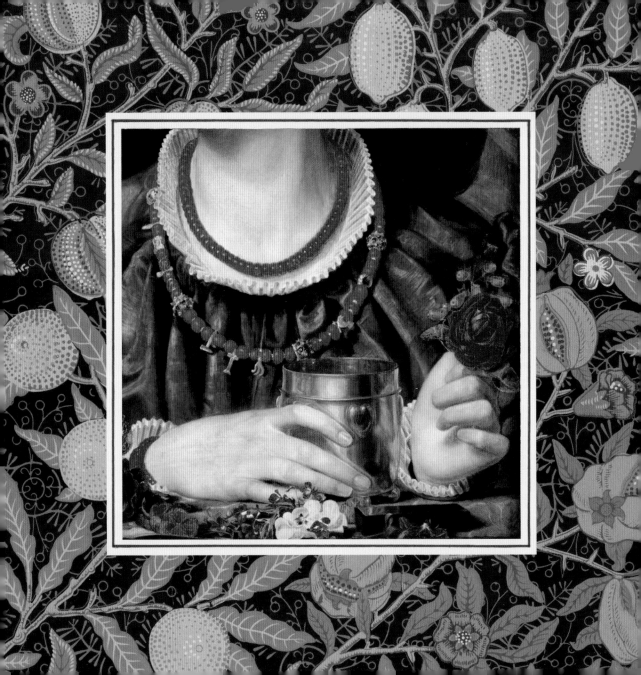

The Fortune-Teller

by Thomas Moore
(1779–1852)

Down in the valley come meet me to-night,
 And I'll tell you your fortune truly
As ever 'twas told, by the new-moon's light,
 To a young maiden, shining as newly.

But, for the world, let no one be nigh,
 Lest haply the stars should deceive me;
Such secrets between you and me and the sky
 Should never go farther, believe me.

If at that hour the heavens be not dim,
 My science shall call up before you
A male apparition, – the image of him
 Whose destiny 'tis to adore you.

And if to that phantom you'll be kind,
 So fondly around you he'll hover,
You'll hardly, my dear, any difference find
 'Twixt him and a true living lover.

Down at your feet, in the pale moonlight,
 He'll kneel, with a warmth of devotion –
An ardour, of which such an innocent sprite
 You'd scarcely believe had a notion.

What other thoughts and events may arise,
 As in destiny's book I've not seen them,
Must only be left to the stars and your eyes
 To settle, ere morning, between them.

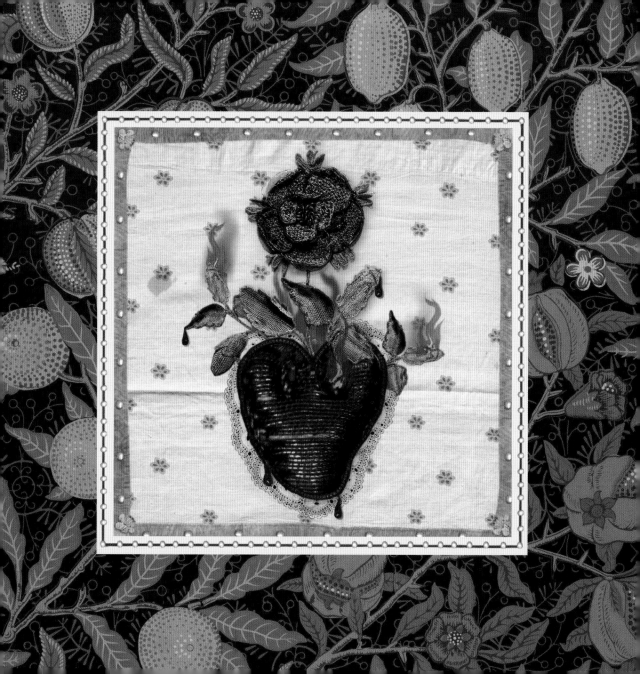

Love Me

by Sara Teasdale
(1884–1933)

Brown-thrush singing all day long
In the leaves above me,
Take my love this April song,
'Love me, love me, love me!'

When he harkens what you say,
Bid him, lest he miss me,
Leave his work or leave his play,
And kiss me, kiss me, kiss me!

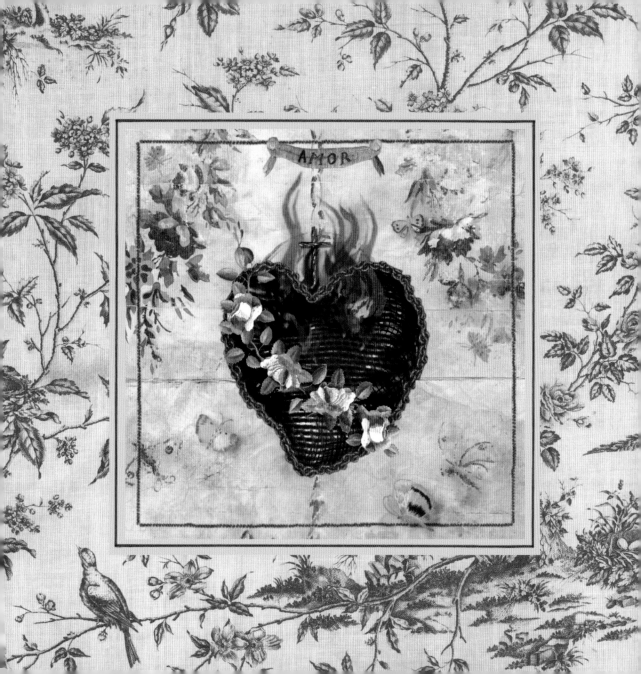

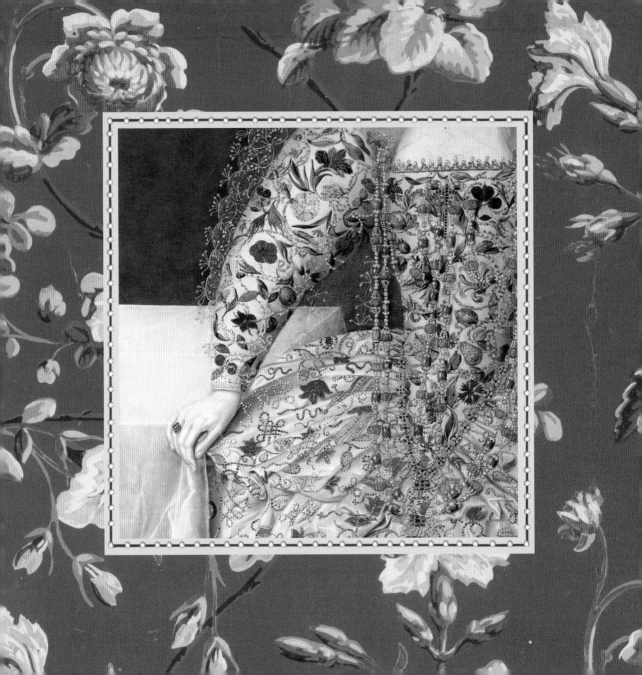

Gloomily the Clouds

by Anne Brontë
(1820–49)

Gloomily the clouds are sailing
O'er the dimly moonlit sky;
Dolefully the wind is wailing;
Not another sound is nigh;

Only I can hear it sweeping
Heathclad hill and woodland dale,
And at times the night's sad weeping
Sounds above its dying wail.

Now the struggling moonbeams glimmer;
Now the shadows deeper fall,
Till the dim light, waxing dimmer,
Scarce reveals yon stately hall.

All beneath its roof are sleeping;
Such a silence reigns around
I can hear the cold rain steeping
Dripping roof and plashy ground.

No: not all are wrapped in slumber;
At yon chamber window stands
One whose years can scarce outnumber
The tears that dew his clasped hands.

From the open casement bending
He surveys the murky skies,
Dreary sighs his bosom rending;
Hot tears gushing from his eyes.

Now that Autumn's charms are dying,
Summer's glories long since gone,
Faded leaves on damp earth lying,
Hoary winter striding on,

'Tis no marvel skies are lowering,
Winds are moaning thus around,
And cold rain, with ceaseless pouring,
Swells the streams and swamps the ground;

But such wild, such bitter grieving
Fits not slender boys like thee;
Such deep sighs should not be heaving
Breasts so young as thine must be.

Life with thee is only springing;
Summer in thy pathway lies;
Every day is nearer bringing
June's bright flowers and glowing skies.

Ah, he sees no brighter morrow!
He is not too young to prove
All the pain and all the sorrow
That attend the steps of love.

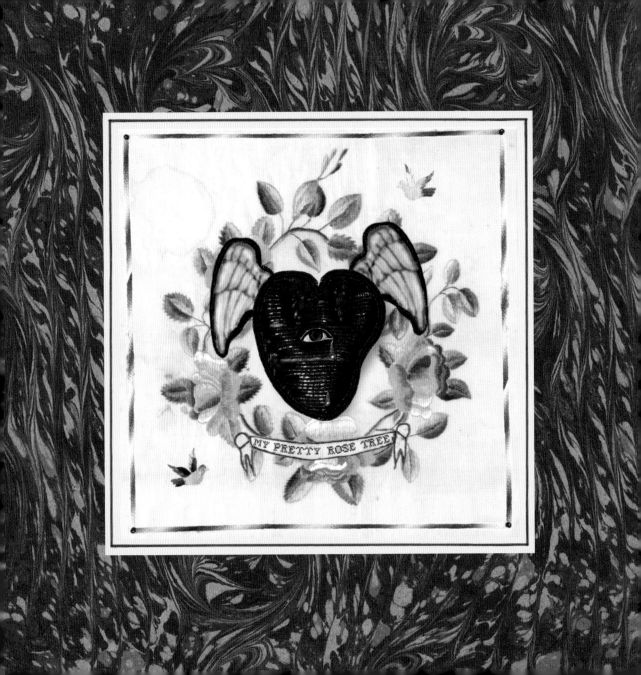

MY PRETTY ROSE TREE

A Dead Rose

by Elizabeth Barrett Browning
(1806–61)

O Rose! who dares to name thee?
No longer roseate now, nor soft, nor sweet;
But pale, and hard, and dry, as stubble-wheat,
Kept seven years in a drawer, thy titles shame thee.

The breeze that used to blow thee
Between the hedgerow thorns, and take away
An odour up the lane to last all day,
If breathing now, unsweetened would forego thee.

The sun that used to smite thee,
And mix his glory in thy gorgeous urn,
Till beam appeared to bloom, and flower to burn,
If shining now, with not a hue would light thee.

The dew that used to wet thee,
And, white first, grow incarnadined, because
It lay upon thee where the crimson was,
If dropping now, would darken where it met thee.

The fly that lit upon thee,
To stretch the tendrils of its tiny feet,
Along thy leaf's pure edges, after heat,
If lighting now, would coldly overrun thee.

The bee that once did suck thee,
And build thy perfumed ambers up his hive,
And swoon in thee for joy, till scarce alive,
If passing now, would blindly overlook thee.

The heart doth recognize thee,
Alone, alone! The heart doth smell thee sweet,
Doth view thee fair, doth judge thee most complete,
Though seeing now those changes that disguise thee.

Yes, and the heart doth owe thee
More love, dead rose! than to such roses bold
As Julia wears at dances, smiling cold!
Lie still upon this heart which breaks below thee!

A Rose

by Emily Dickinson
(1830–86)

A sepal, petal, and a thorn
Upon a common summer's morn,
A flash of dew, a bee or two,
A breeze
A caper in the trees, –
And I'm a rose!

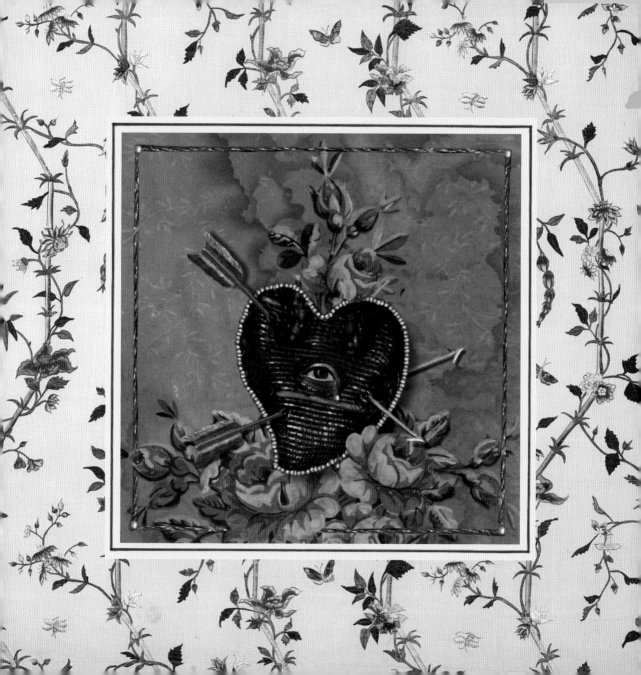

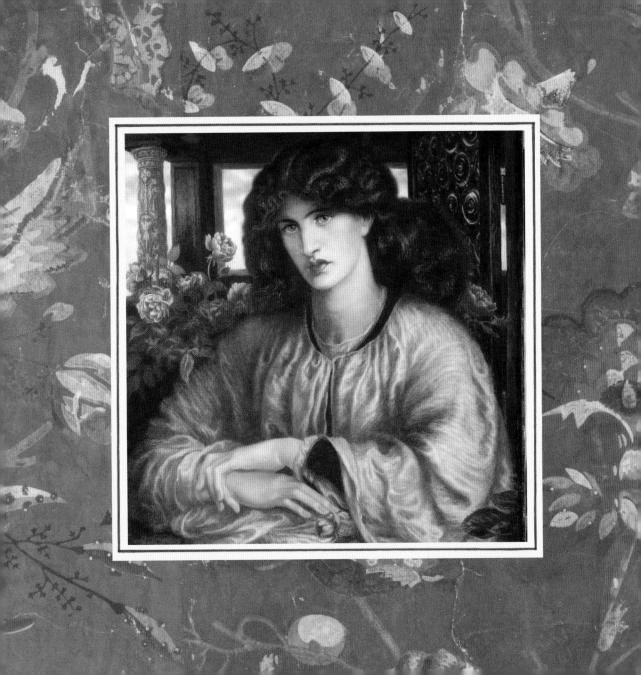

The Sonnets XXXI

Thy bosom is endearèd with all hearts

by William Shakespeare
(1564–1616)

Thy bosom is endearèd with all hearts,
Which I by lacking have supposèd dead,
And there reigns love, and all love's loving parts,
And all those friends which I thought burièd.
How many a holy and obsequious tear
Hath dear religious love stol'n from mine eye
As interest of the dead, which now appear
But things removed that hidden in thee lie.
Thou art the grave where buried love doth live,
Hung with the trophies of my lovers gone,
Who all their parts of me to thee did give;
That due of many now is thine alone:
Their images I loved I view in thee,
And thou, all they, hast all the all of me.

The Lover Tells of
the Rose in His Heart

by William Butler Yeats
(1865–1939)

All things uncomely and broken, all things worn out and old,
The cry of a child by the roadway, the creak of a lumbering cart,
The heavy steps of the ploughman, splashing the wintry mould,
Are wronging your image that blossoms a rose in
 the deeps of my heart.

The wrong of unshapely things is a wrong too great to be told;
I hunger to build them anew and sit on a green knoll apart,
With the earth and the sky and the water, re-made, like
 a casket of gold
For my dreams of your image that blossoms a rose in
 the deeps of my heart.

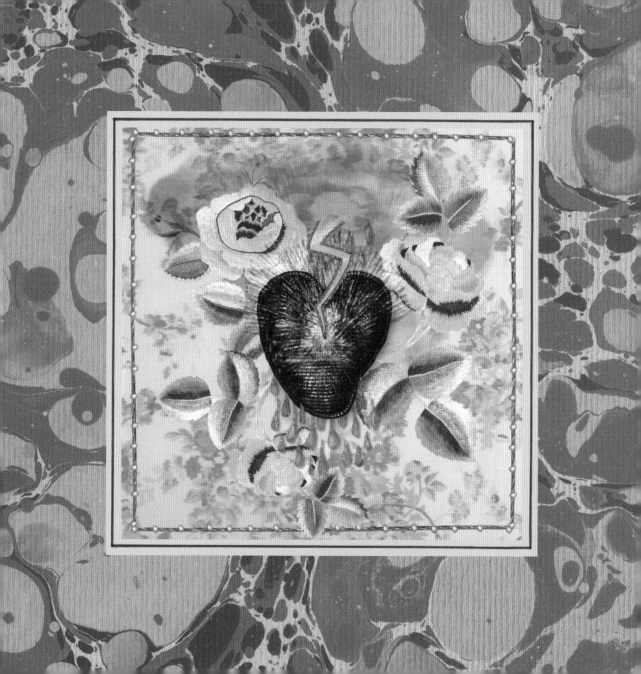

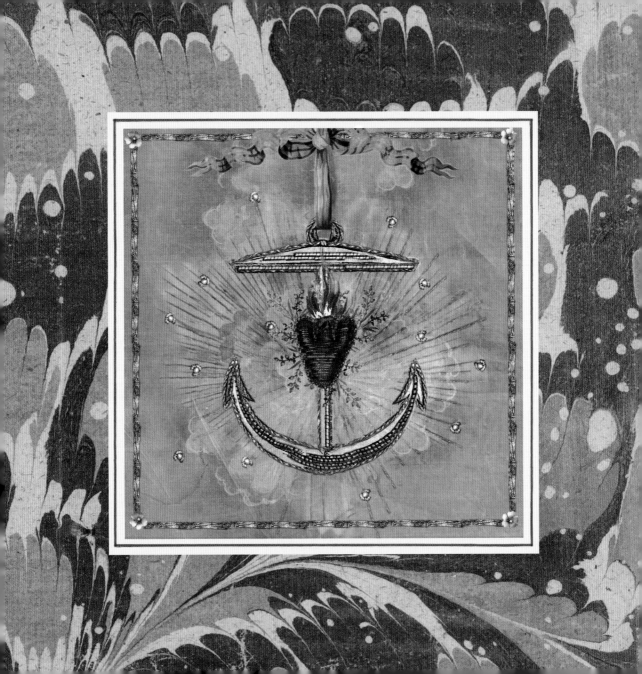

Love and Hope
(Swiss Air)

by Thomas Moore
(1779–1852)

At morn, beside yon summer sea,
 Young Hope and Love reclined;
But scarce had noon-tide come, when he
Into his bark leapt smilingly,
 And left poor Hope behind.

'I go,' said Love, 'to sail awhile
 Across this sunny main';
And then so sweet, his parting smile,
That Hope, who never dreamt of guile,
 Believed he'd come again.

She lingered there till evening's beam
 Along the waters lay;
And o'er the sands, in thoughtful dream,
Oft traced his name, which still the stream
 As often washed away.

At length a sail appears in sight,
 And toward the maiden moves!
'Tis Wealth that comes, and gay and bright,
His golden bark reflects the light,
 But ah! it is not Love's.

Another sail – 'twas Friendship showed
 Her night-lamp o'er the sea;
And calm the light that lamp bestowed;
But Love had lights that warmer glowed,
 And where, alas! was he?

Now fast around the sea and shore
 Night threw her darkling chain;
The sunny sails were seen no more,
Hope's morning dreams of bliss were o'er –
 Love never came again!

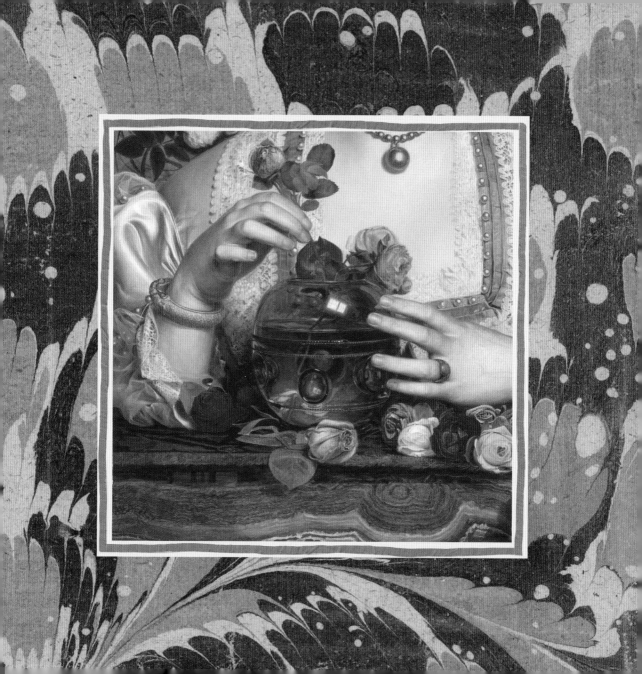

The Lover Mourns for the Loss of Love

by William Butler Yeats
(1865–1939)

Pale brows, still hands and dim hair,
I had a beautiful friend
And dreamed that the old despair
Would end in love in the end:
She looked in my heart one day
And saw your image was there;
She has gone weeping away.

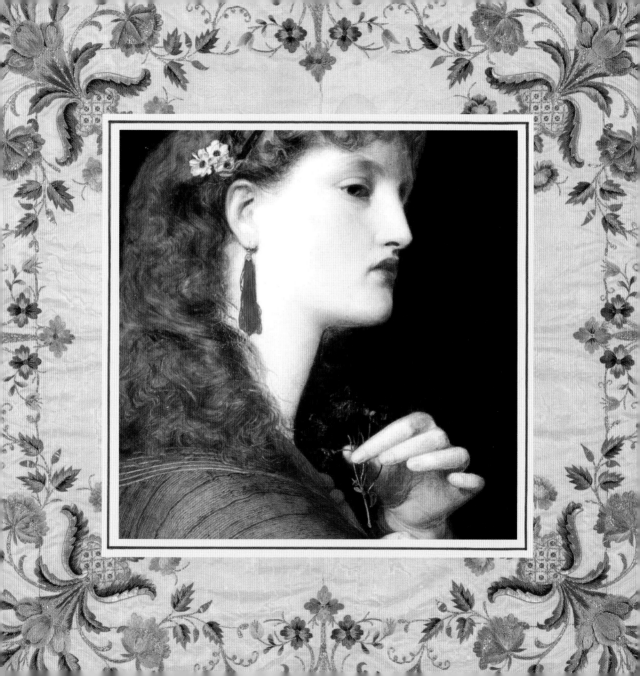

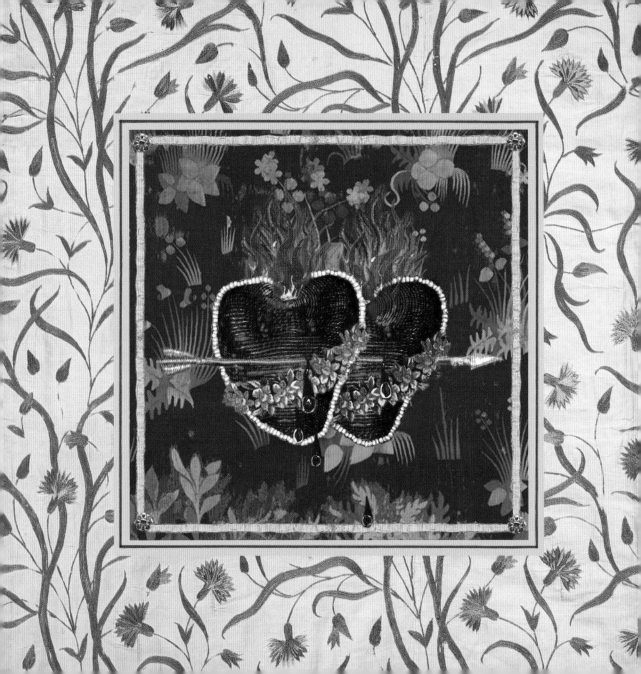

Buona Notte

by Percy Bysshe Shelley
(1792–1822)

1. 'Buona notte, buona notte!' – Come mai
 La notte sarà buona senza te?
 Non dirmi buona notte, – che tu sai,
 La notte sa star buona da per se.

2. Solinga, scura, cupa, senza speme,
 La notte quando Lilla m'abbandona;
 Pei cuori chi si batton insieme
 Ogni notte, senza dirla, sarà buona.

3. Come male buona notte ci suona
 Con sospiri e parole interrotte! –
 Il modo di aver la notte buona
 E mai non di dir la buona notte.

Love Lies Bleeding

by Christina Rossetti
(1830–94)

Love that is dead and buried, yesterday
Out of his grave rose up before my face;
No recognition in his look, no trace
Of memory in his eyes dust-dimmed and grey.
While I, remembering, found no word to say,
But felt my quickened heart leap in its place;
Caught afterglow thrown back from long set days,
Caught echoes of all music passed away.
Was this indeed to meet? – I mind me yet
In youth we met when hope and love were quick,
We parted with hope dead, but love alive:
I mind me how we parted then heart sick,
Remembering, loving, hopeless, weak to strive: –
Was this to meet? Not so, we have not met.

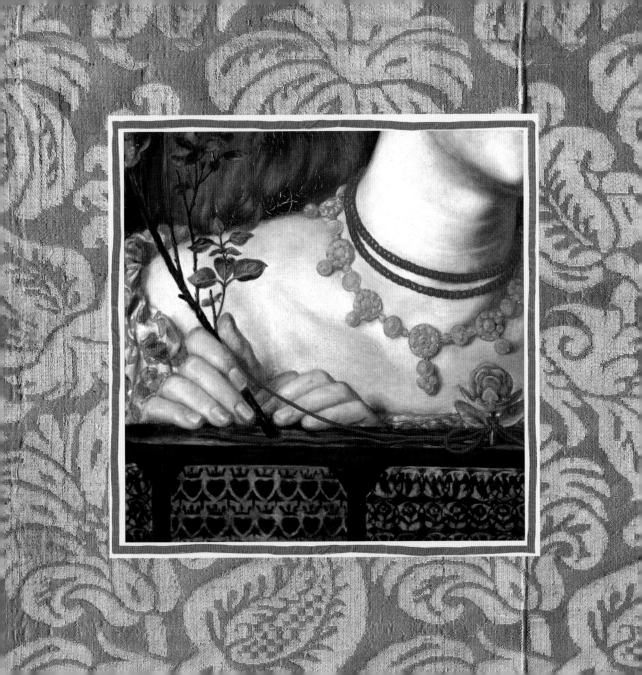

Hope is a Subtle Glutton

by Emily Dickinson
(1830–86)

Hope is a subtle glutton;
He feeds upon the fair;
And yet, inspected closely,
What abstinence is there!

His is the halcyon table
That never seats but one,
And whatsoever is consumed
The same amounts remain.

CREDITS

PORTRAITS AND MINIATURES

p. 8 *Portrait of a Lady*, attributed to William Larkin / Private collection.

p. 12 *Portrait of a Woman*, Nicholas Hilliard / The Edward B. Greene Collection, Cleveland Museum of Art, Ohio.

p. 16 *Eye Miniature on an Elliptical Ivory Box* / Smithsonian American Art Museum.

p. 19 *Portrait of Anne Newdigate and Mary Fitton*, unknown artist / British Library / Private collection.

p. 23 *Portrait of a Lady, masqued as Flora*, Isaac Oliver / Rijksmuseum, Amsterdam.

p. 27 *Eye*, Portrait Miniature / Gift of Mr and Mrs John W. Starr, Cleveland Museum of Art, Ohio.

p. 32 *Perdita*, Frederick Sandys / Private collection.

p. 36 *Love's Shadow*, Frederick Sandys / Private collection.

p. 44 *Portrait of Queen Elizabeth I*, Nicholas Hilliard / Walker Art Gallery, Liverpool.

p. 50 *Ophelia*, Thomas Francis Dicksee / Bilbao Fine Arts Museum, Spain.

p. 54 *Rosa Triplex*, Dante Gabriel Rossetti / Private collection.

p. 61 *Portrait of an Unknown Lady*, Lucas Horenbout / Yale Center for British Art, Paul Mellon Collection.

p. 63 *Frances Howard, dowager Countess of Kildare*, unknown artist / Weiss Gallery, London.

p. 69 *Portrait of Lucy Russell, Countess of Bedford, née Harrington*, Isaac Oliver / The Edward B. Greene Collection, Cleveland Museum of Art, Ohio.

p. 76 *Vase of Flowers*, Jan van Huysum / J. Paul Getty Museum.

p. 80 *Elizabeth Howard, Lady Southwell (c.1564–1646)*, unknown artist / Weiss Gallery, London.

p. 87 *Jane Morris: Study for 'Mariana'*, Dante Gabriel Rossetti / Gift of Jessie Lemont Trausil, 1947, Metropolitan Museum of Art, New York.

p. 89 *Vase with Flowers*, Jan van Huysum / Dulwich Picture Gallery.

p. 94 *Isolda with the Love Potion*, Frederick Sandys / Museo de Arte de Ponce, Puerto Rico.

p. 100 *Catherine Carey, Countess of Nottingham (1547–1603)*, Robert Peake the Elder / Weiss Gallery, London.

p. 110 *La Donna della Finestra*, Dante Gabriel Rossetti / Harvard Art Museums / Fogg Museum, Bequest of Grenville L. Winthrop.

p. 117 *Grace Rose*, Frederick Sandys / Yale Center for British Art, Paul Mellon Fund.

p. 119 *May Margaret*, Frederick Sandys / Samuel and Mary R. Bancroft Memorial, 1935, Delaware Art Museum.

p. 123 *Fair Rosamund*, Dante Gabriel Rossetti / National Museum Wales, Cardiff.

BACKGROUNDS

p. 6 Gift of Mrs Philip White, Cleveland Museum of Art, Ohio.

p. 8 Purchased with funds contributed by Mrs Alfred Stengel, from the Henri Clouzot Collection, 1929, Philadelphia Museum of Art.

p. 11 Gift of The United Piece Dye Works, 1936, Metropolitan Museum of Art, New York.

p. 12 Dodge Fund, 1967, Metropolitan Museum of Art, New York.

p. 15 Gift of The United Piece Dye Works, 1936, Metropolitan Museum of Art, New York.

p. 16 Anne Marie de Samarjay Fund, 1975, Metropolitan Museum of Art, New York.

p. 19 Cooper Hewitt, Smithsonian Design Museum, New York.

p. 20 Rogers Fund, 1966, Metropolitan Museum of Art, New York.

p. 23 Gift of Mrs Luke Vincent Lockwood, Cooper Hewitt, Smithsonian Design Museum, New York.

pp. 24 & 27 Gift of John Sloane, 1931, Metropolitan Museum of Art, New York.

p. 28 Rogers Fund, 1938, Metropolitan Museum of Art, New York.

p. 32 Dudley P. Allen Fund, Cleveland Museum of Art, Ohio.

pp. 36, 38–39 & 41 Dudley P. Allen Fund, Cleveland Museum of Art, Ohio.

p. 43 Rogers Fund, 1983, Metropolitan Museum of Art, New York.

pp. 44 & 47 Gift of the Metropolitan Museum of Art, Cooper Hewitt, Smithsonian Design Museum, New York.

p. 49 Museum Accession, Metropolitan Museum of Art, New York.

p. 50 Gift of John Judkyn, Cooper Hewitt, Smithsonian Design Museum, New York.

pp. 54 & 57 Gift of Jones and Erwin, Inc., Cooper Hewitt, Smithsonian Design Museum, New York.

p. 63 The Nuttall Collection, Gift of Mrs Magdalena Nuttall, 1908, Metropolitan Museum of Art, New York.

p. 69 Museum Purchase through gift of Mary Hearn Greims, Cooper Hewitt, Smithsonian Design Museum, New York.

p. 75 Gift of Mrs Hampton Lawrence Carson, 1915, Metropolitan Museum of Art, New York.

p. 76 Rogers Fund, 1924, Metropolitan Museum of Art, New York.

pp. 80 & 83 Cooper Hewitt, Smithsonian Design Museum, New York.

p. 89 Rogers Fund, 1927, Metropolitan Museum of Art, New York.

p. 90 Rogers Fund, 1959, Metropolitan Museum of Art, New York.

pp. 94 & 97 Gift of Cowtan & Tout, Inc., Cooper Hewitt, Smithsonian Design Museum, New York.

p. 99 Rogers Fund, 1917, Metropolitan Museum of Art, New York.

pp. 100 & 102–103 Donated by Josephine Howell, Cooper Hewitt, Smithsonian Design Museum, New York.

p. 109 Rogers Fund, 1939, Metropolitan Museum of Art, New York.

p. 110 Gift of Harvey Smith, Cooper Hewitt, Smithsonian Design Museum, New York.

p. 119 Gift of J. H. Wade, Cleveland Museum of Art, Ohio.

p. 120 Anonymous Gift, 1949, Metropolitan Museum of Art, New York.

p. 123 Rogers Fund, 1909, Metropolitan Museum of Art, New York.

p. 124 Purchase, The James Parker Charitable Foundation Gift, 2013, Metropolitan Museum of Art, New York.

ACKNOWLEDGMENTS

I want to thank from the depths of my heart:

Florence Welch, for the most beautiful words I could ever imagine written for this book. For believing in what I create. Il mio cuore è il tuo cuore.

My love, Kenny Spooren, for always being by my side, for his love and for being my other half.

Amy Weller, for making many things possible.

My parents, for always being my support.

Lucienne O'Mara, for giving me the opportunity to put this book together.

My editor, Louise Dixon, for being a wonderful companion on this project.

Andrews McMeel Publishing
a division of Andrews McMeel Universal
1130 Walnut Street, Kansas City, Missouri 64106

www.andrewsmcmeel.com

21 22 23 24 25 SHO 10 9 8 7 6 5 4 3 2 1

ISBN: 978-1-5248-6308-1

Library of Congress Control Number: 2021943416

Editor: Katie Gould
Art Director: Tiffany Meairs
Production Editor: Meg Daniels
Production Manager: Carol Coe

ATTENTION: SCHOOLS AND BUSINESSES
Andrews McMeel books are available at quantity
discounts with bulk purchase for educational, business,
or sales promotional use. For information, please e-mail the
Andrews McMeel Publishing Special Sales Department:
specialsales@amuniversal.com.

FSC
www.fsc.org
MIX
Paper from
responsible sources
FSC® C109093